LEGENDARY LOCALS

OF

AMESBURY

MASSACHUSETTS

Always follow your dreams!

Margie Walker

MARGIE WALKER

LEGENDARY
LOCALS

Legendary Locals is an imprint of Arcadia Publishing
Charleston, South Carolina

Printed in the United States of America

Library of Congress Control Number: 2013943848

For all general information, please contact Arcadia Publishing:
Telephone 843-853-2070
Fax 843-853-0044
E-mail sales@arcadiapublishing.com
For customer service and orders:
Toll-Free 1-888-313-2665

Visit us on the Internet at www.arcadiapublishing.com

Dedication
This book is dedicated to my husband, Joey Walker; my parents, Natalie and Roy Shepard; Margie and Jack Hart; and all the wonderful people of Amesbury, both past and present.

On the Front Cover: Clockwise from top left:
Lucy Grogan, bringing relief to children with cancer (Courtesy of Beecher Grogan; see page 112), Alanson Currier, Civil War prisoner (Courtesy of Sally Lavery; see page 75), John Abbott Douglass, doctor at Gettysburg (Courtesy of the Amesbury Public Library Local History Collection; see page 21), Jeffrey Donovan, actor (Courtesy of Jeffrey Donovan; see page 62), Elizabeth Whittier, abolitionist (Courtesy of the Amesbury Public Library Local History Collection; see page 51), Annie Webster, first selectwoman (Courtesy of the Amesbury Public Library Local History Collection; see page 15), Rosemary Werner, community activist (Photograph by Joey Walker; see page 118).

On the Back Cover: From left to right:
Gregory Hoyt, actor (Courtesy of Gregory Hoyt, photograph by Margie Walker and Gregory Hoyt; see page 61); the Boston & Maine Railroad Station on Water Street (Courtesy of the Amesbury Public Library Local History Collection; see page 8).

CONTENTS

ACKNOWLEDGMENTS

I would like to thank all of the local historians and families that documented Amesbury history and donated material to the Amesbury Public Library. I would like to specifically thank the following people and institutions: Chris Deorocki, photographer Joey Walker, Beecher Grogan, Virginia Page, Holly Shay, Greg Hoyt, Patty Hoyt, Peter Hoyt, Dianne Cole, Amesbury Police Department, Janet Geanoulis, Karen Martel, Peter Dearborn, Aleta Estabrook, Joan Miller, Douglas Wood, Gay Main, William Ellis, Marc Bourgeois, Julie Capp Cairol, Dennis Iworsky, Ronald Fuller, Market Street Baptist Church, Amesbury Improvement Association, Amesbury Public Library, and Patricia Stano Carpenter, and Suzanne Cote. Unless otherwise noted, all images and research material are courtesy of the Amesbury Public Library Local History Collection.

INTRODUCTION

It is an honor to write a book about Amesbury. I used the resources at the Amesbury Public Library to find stories of people who have made a difference in Amesbury—those who went the extra mile, dreamed of stardom, persevered in the face of adversity, made a difference in other people's lives, and made Amesbury a better place to live. It was not possible to include everyone who makes Amesbury the community it is today, but this book features a cross-section of such people.

I hope that people learn about the rich history of Amesbury through the carriage-makers, trolley manufacturers, artists, actors, abolitionists, teachers, writers, historians, shipbuilders, business owners, veterans, and those who gave their lives.

The settlement of Amesbury was incorporated in 1668. Along the Merrimack River, evidence was found of Native American settlement, including various relics and extensive shell mounds. The first settlers, venturing into the woods along the coast, were fortunate that few Native Americans remained to assert their rights and to inflict harm on them. Native people contracted a disease, either smallpox or yellow fever, and many of them lost their lives.

One of the earliest industries was splitting staves from oak trees. Richard Currier and Thomas Macy were permitted to build another sawmill to keep up with demand. William Osgood built a sawmill across the Powow River.

Amesbury continued to grow, with shipbuilding along the Merrimack River. William Hackett was busy building vessels, and the Lowells were building right alongside of them. Lowell's Boat Shop is still in existence today. People started moving to Amesbury from Poland, Scotland, Ireland, and Canada. The French and the Polish organized their own clubs so they could help people adjust to their new homes. Amelia Earhart taught English as a second language to factory workers at Biddle and Smart.

Carriage manufacturing was a major reason that people were flocking to Amesbury. There were a lot of opportunities for employment. The Merrimack Hat Company was also a major employer.

The W.E. Fuller Company opened its doors in 1894. It sold Boy Scout uniforms, tuxedos, and other apparel. Ronald Fuller was the fourth generation to operate the business. Residents have fond memories of buying school items at Fuller's. In July 2013, the W.E. Fuller Company closed its doors, as Ronald Fuller retired. For 119 years, the store contributed to downtown and to the Amesbury community.

The Boston & Maine Railroad and Ellis Trolleys allowed people to come and go from Amesbury to other local communities. The trolleys were manufactured in Amesbury by the William Ellis Company.

Women played an important role in the community. They started charitable organizations to help the less fortunate, they taught school, were nurses during wartime, and served as historians, selectwomen, singers, writers, abolitionists, veterans, librarians, and leaders.

Amesbury residents served the nation in the Revolutionary War, Civil War, Spanish-American War, Korean War, World I, World War II, Vietnam War, Gulf War, War on Terror, and Operation Enduring Freedom. Many Amesbury men and women were lost in these wars. Memorials throughout town serve as reminders of their sacrifices. On Veterans Day and Memorial Day, local veterans visit the memorials and have a service. Heroes walk among us every day.

The Amesbury Public Library has been an institution since 1902. Trustees to the library have included carriage makers, automobile manufacturers, poets, writers, teachers, reporters, historians, and people interested in the library.

In 1996, Amesbury changed from a town form of government to a city form of government. Charters were written, a mayor was elected, and the City of Amesbury was born.

Amesbury continues to grow and evolve and to improve on its resources. Local history is being kept alive through the Amesbury treasures found in the Bartlett Museum, Macy Colby House, the Hat

Museum, Carriage Museum, Mary Baker Eddy/Squire Bagley House, Whittier Home, Lowell's Boat Shop, Amesbury Public Library, Amesbury Improvement Association, Rocky Hill Meeting House, and Salisbury Point Station and Museum.

People come here from all over the world to find their ancestors, to walk the streets where their families once lived, and to see where those ancestors worked. Earlier residents built this city from the ground up, from the banks of the Powow River to Carriage Hill, to Lions Mouth, to downtown, and to the Merrimack River, where ships and hats were made. People come here to find their roots.

Amesbury has always been about community. People come together to help one another. When another community, near or far, needs help or has experienced a disaster, Amesbury offers to help. Residents may sign a book expressing concern, send Valentine's cards to a community devastated by gun violence, send care packages to soldiers overseas or to families that suffered loss on September 11, 2001, or attend a vigil for the Boston Marathon bombing. Residents show support to other people, letting them know that Amesbury cares. This is the community that we are proud of. This is Amesbury.

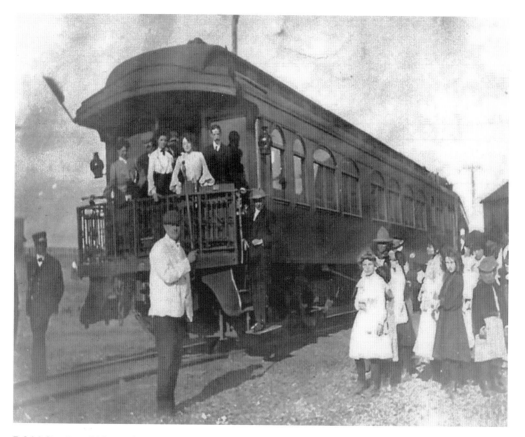

B&M Station, Water Street
The Boston & Maine Railroad Station on Water Street is a very busy place. Here, people wait for their family and friends from destinations unknown.

CHAPTER ONE

History

The importance of history is not merely to preserve our inheritance like a precious fossil in a museum. What is really important is that we give our children an appreciation of the work and deeds of those forefathers and the ability to shape the elements into a new and living pattern—the capacity to adapt a heritage and apply its fine strength and quality to changing conditions. You can't build a house without a foundation, and our ancestors are the foundation of our lives.

—Margaret Rice, Amesbury historian

Native Americans roamed this land long before the first white settlers came. Smallpox wiped out a portion of the Native population. The first settlers immediately began to make Amesbury the city it is today. They established a sawmill along the river to provide the materials necessary to build homes and businesses. They divided land so that people would be able to build. Shipbuilding was going strong along the Merrimack River, and William Ellis was manufacturing horse-drawn trolleys. A meetinghouse was built so that people could worship, and Claude Bourgeois was trying to survive. A suspected witch in Amesbury, Susannah Martin, was hung at the gallows in Salem. Valentine Bagley was lost in the desert while overseas, and he made sure he would never be without water again.

Amesbury has had a strong work ethic since the beginning, when new industry was a major source of employment. The community today embraces the history of Amesbury by accentuating its historic buildings. The mill yard, site of the carriage and automobile industries, has been restored. The Macy Colby House offers a glimpse of life in the 1600s. The Whittier Home gives people an inside look at John Greenleaf Whittier and his sister Elizabeth. People came from Canada, Ireland, Scotland, and Poland to start a new life in Amesbury. They made their mark on Amesbury by creating clubs, societies, and churches. Amesbury's men and women went to war, and some lost their lives. Memorials were built so they would never be forgotten. On Memorial Day, veterans place wreaths on the town's many memorials. Through it all, Amesbury continues to grow and prosper.

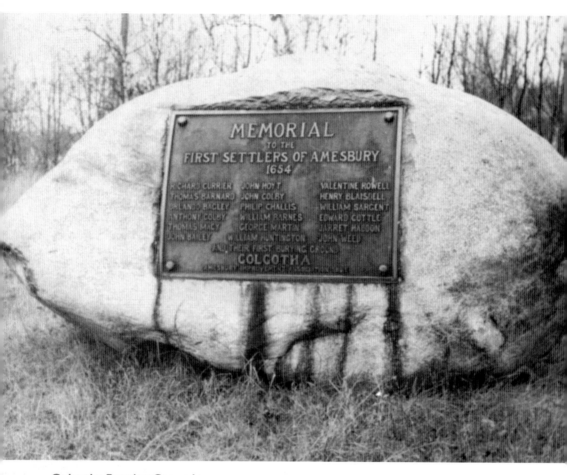

Golgotha Burying Ground
This is a memorial to the first settlers of Amesbury, who arrived in 1664. They were Richard Currier, Thomas Barnard, Orlando Bagley, Anthony Colby, Thomas Macy, John Bailey, John Hoyt, John Colby, Philip Challis, William Barnes, George Martin, William Huntington, Valentine Rowell, Henry Blaisdell, William Sargent, Edward Cottle, Jarret Haddon, and John Weed. It is not known if the settlers are buried here or at another cemetery. (Image courtesy of the Local History Collection of the Amesbury Public Library.)

William Osgood

Osgood (1609–1700), a carpenter and millwright, supplied lumber for the board houses that replaced the log cabins along the river. Osgood Mill was in the north channel of the Powow River, which flows through the No. 2 mill, on the south side of High Street. He also operated a gristmill on the Powow at a later, unknown date. Osgood was sought by leaders of the Bay Colony, who granted him large parcels of land. In 1644, he began building his home on Congress Street. In 1969, his house was dismantled and moved to Dover, Massachusetts.

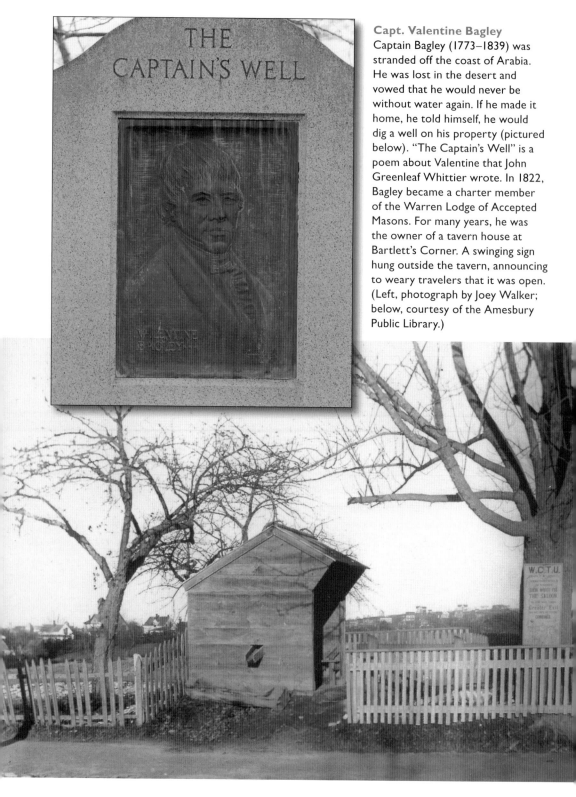

Capt. Valentine Bagley
Captain Bagley (1773–1839) was stranded off the coast of Arabia. He was lost in the desert and vowed that he would never be without water again. If he made it home, he told himself, he would dig a well on his property (pictured below). "The Captain's Well" is a poem about Valentine that John Greenleaf Whittier wrote. In 1822, Bagley became a charter member of the Warren Lodge of Accepted Masons. For many years, he was the owner of a tavern house at Bartlett's Corner. A swinging sign hung outside the tavern, announcing to weary travelers that it was open. (Left, photograph by Joey Walker; below, courtesy of the Amesbury Public Library.)

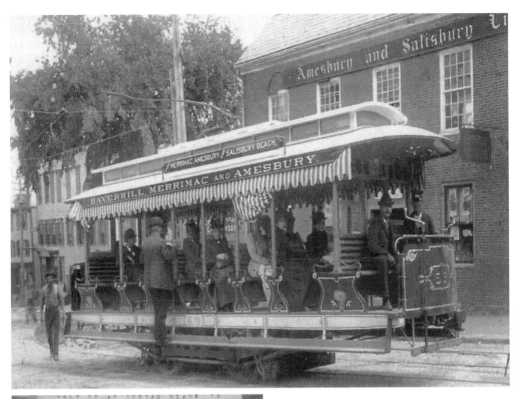

William Ellis

Ellis, born in Scotland, had spent time in the gold fields of Australia, acquiring a considerable fortune. When he returned to Scotland, he found a discarded copy of the *Villager*, an Amesbury newspaper, announcing the opening of Mill No. 8. In 1863, he came here to work for James Hume. Ellis started his own carriage company in 1875, producing horse-drawn streetcars and, later, electric-powered trolleys.

Batt Moulton

Moulton was born in Newbury, Massachusetts, in 1688, to William and Abigail Webster Moulton. He moved to Amesbury and married Jemina George. He lived near the river at South Amesbury, now Merrimacport. He sold an Indian man by the name of James, age 27, to Nathaniel Dole of Newbury for £25 on November 3, 1730.

13

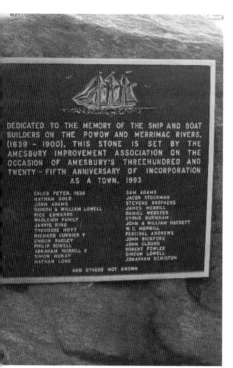

Shipbuilders

This memorial is dedicated to the following "ship and boat builders," spanning 1639 to 1900: Caleb Peter, Sam Adams, Nathan Gold, Jacob Stockman, John Adams, Stevens Brothers, Gideon and William Lowell, James Merrill, Rice Edwards, Daniel Webster, Wadleigh Family, Cyrus Burnham, Jarvis Ring, John and William Hackett, Theodore Hoyt, W.C. Morrill, Richard Currier, Percival Andrews, Enoch Bagley, John Bickford, Philip Rowell, John Clough, Abraham Morrill, Robert Fowler, Simon McKay, Simeon Lowell, Nathan Long, and Jonathan Keniston. These men built ships that were used by the Continental Congress. (Courtesy of Amesbury Improvement Association; photograph by Joey Walker.)

Alliance

The *Alliance* was built by John and William Hackett. It was one of the most famous vessels that came out of Amesbury. The *Alliance* was among the squadron of vessels assigned to Capt. John Paul Jones. It is believed that General Lafayette made three crossings of the Atlantic in the *Alliance*. Congress ordered the vessel be sold in 1785. It was sold at auction for $7,700. (Courtesy Amesbury Improvement Association; photograph by Joey Walker.)

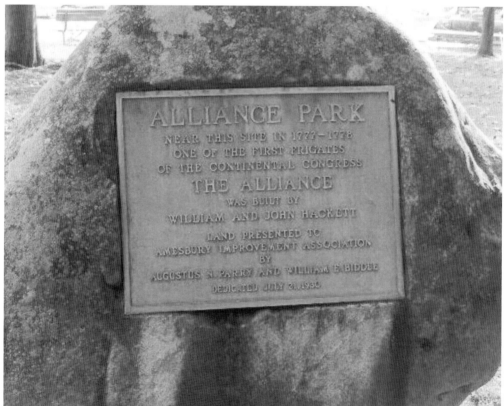

Annie Webster

Webster (1879–1963) was the chief selectwoman for the town. She ran the welfare department, was chairwoman of the licensing board, and served as a policewoman. She raced to fires, and firemen feared she would jump in the truck and drive. When she passed away, she left $15,000 to charitable and educational institutions. She left the rest to her four dogs and four cats.

Amelia Earhart

In 1926, Earhart contacted Biddle and Smart, which employed many foreign workers, to teach English. She taught the "Miller Course of Correct English" in Amesbury from March 16 to June 22, 1926. She went on to become the first woman to cross the Atlantic Ocean by airplane. (Image courtesy of Library of Congress.)

15

The Hacketts
The Hacketts were shipbuilders in Amesbury and Salisbury. The Navy was fond of William Hackett's designs, which featured sleek lines and were built for speed. He was known throughout the community for his excellent workmanship. The *Alliance* is among the Hacketts' great vessels. The Hackett homestead is seen in this photograph.

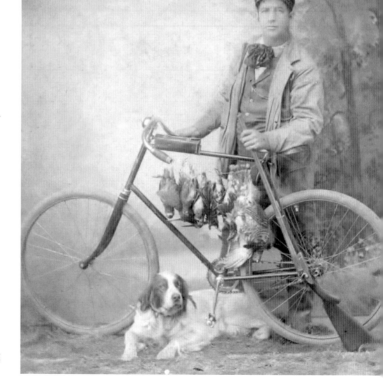

Charles Sawyer
Sawyer was born in 1860. As seen here, he used his bicycle to go hunting. He got quite a catch on this day. His trusty dog helped him retrieve the birds.

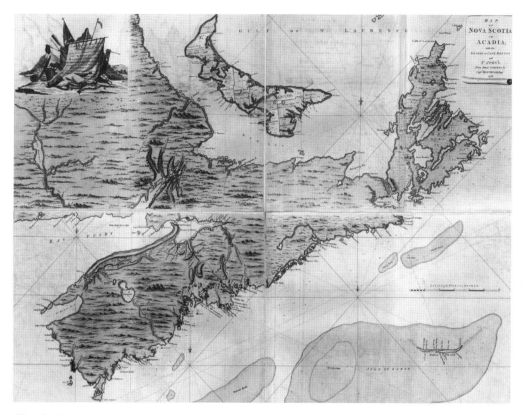

Claude Bourgeois

Bourgeois was born in 1695 in Beaubassin, Acadia, the first colony outside of Port-Royal to be settled by Acadians. In 1721, he married Marie Marguerite LeBlanc, and the couple had 12 children. Church records of Port-Royal clearly show that he lived in the Annapolis Valley area until 1750. It is believed that Bourgeois and his family remained on the farm until 1755. The Acadians discussed their response to the oath, deciding in the end to refuse it. They had already taken an oath of allegiance to the crown of England, and they wished to maintain neutral in any war among the English, French, and Native peoples. Bourgeois and his family were transported to Amesbury on the ship *Helena* on January 5, 1756. They arrived in a town in which many of its men had been injured or killed in the French and Indian War. The Bourgeois family was seen as the enemy within the community. Selectmen took two of his daughters to be bound out for service, according to the law. Bourgeois filed a petition stating that his family relied on their daughters to spin flax and wool, which they had saved from Annapolis. As the town had withheld the family's subsistence, he had received nothing at all for 14 days. The family was in danger of starving, and the owner of the house wanted the rent. But the family relied on the daughters' work for income. The town's response was that the French neutrals be treated with humanity. It is believed that Bourgeois died in 1760. It is unknown where he is buried. (Courtesy of Marc Bourgeois; photograph courtesy of the Library of Congress.)

Horace G. Leslie
Leslie (1842–1907) was born in Haverhill and settled in Amesbury in 1868. He was an assistant surgeon for two years during the Civil War. He served on the school committee, town improvement association, and Bartlett Cemetery's board. Leslie served the town in the legislature for two terms. He was a library trustee for 10 years. A poet, he recited his work during Memorial Day and other events in town.

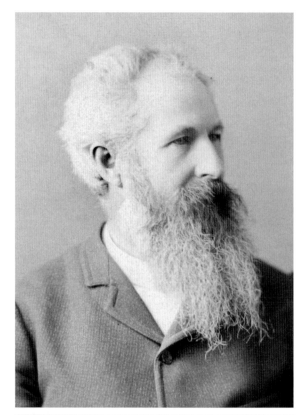

Hannah Ordway Cunningham
Cunningham was born in Amesbury in 1818 to William and Lucy Ordway. She entered Mount Holyoke Female Seminary and graduated as valedictorian of her class. In 1841, she and her husband, Oliver, opened the Liberty Male and Female Seminary in Liberty, Missouri. The DAR Women in American History Award was given to Hannah's descendants in 2007. She died in 1901 in Missouri. (Courtesy of Patricia Stano-Carpenter.)

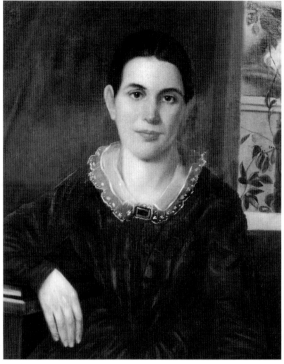

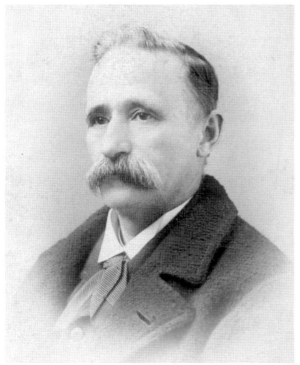

Jacob R. Huntington
Huntington was born in 1830. He learned the trade of yarn spinning when he was a boy at the Salisbury Mills. He then went on to paint carriages. Huntington is known for being the father of the carriage industry. He helped many people in town financially and expected nothing in return. He donated the Josiah Bartlett statue in Huntington Square.

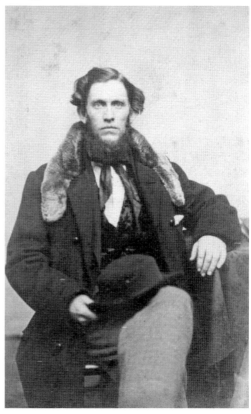

Moses Newell Huntington
Moses Huntington was born in 1833 in Amesbury. He worked in his home as a shoemaker. An amateur ornithologist, paleontologist, and botanist, he collected hundreds of flora, fauna, and geological specimens indigenous to the region. He found large numbers of gouges, arrowheads, and implements at the old Indian ground. His estate donated $15,459.45 to the Amesbury Public Library.

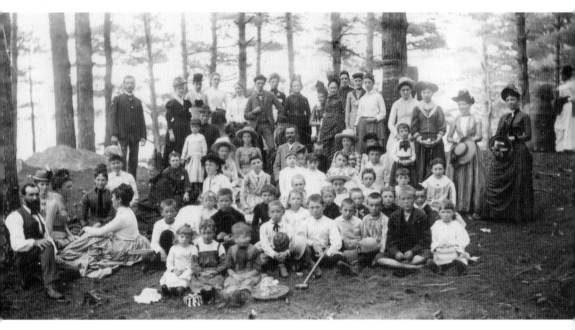

Huntington Reunion

A Huntington reunion was held on September 25, 1884. Jacob Huntington made the opening remarks. The opening and the parting hymns were written and read by Rev. Cyrus Huntington, and a poem was read by Rev. Gurdon Huntington. Dinner was served at 1:30 p.m. A hymn was written by Mrs. John W. James, daughter of Ralph Huntington. M.N. Huntington read the historical address, and a poem was written for the occasion by Dr. Homer Huntington of California.

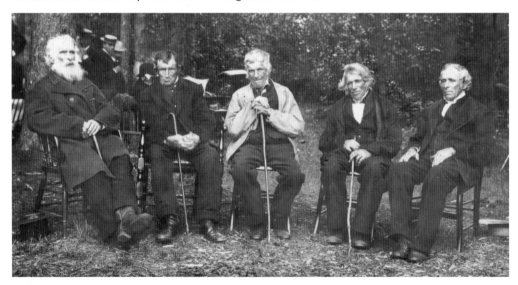

Huntington Brothers

This photograph was most likely taken at the Huntington family reunion in 1884. The Huntington brothers are (in no particular order) Enoch (born 1794), John (born 1797), Jacob (born 1801), Daniel (born 1806), and Moses (born 1809). Jacob bought and donated the Josiah Bartlett statue that is in Huntington Square. Moses donated money and items to the Amesbury Public Library.

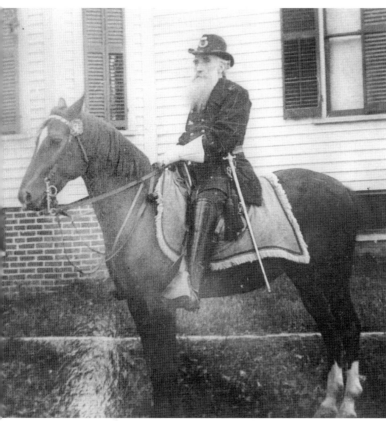

John Abbott Douglass
Dr. Douglass (1827–1916) graduated from Bowdoin College in 1854 and the College of Physicians and Surgeons in 1862. He enlisted in the 11th Regiment of Massachusetts Volunteers as an assistant surgeon. Dr. Douglass was at Gettysburg in July 1863. He had a hand in attempting to save many of the nearly 15,000 Union men wounded in the battle. He was discharged in 1864. A well-respected doctor in town, he delivered 1,786 babies from 1866 to 1913.

Moses Tunstall
Moses, a liberated slave, came back from the South with Dr. John Abbott Douglass. He watched Douglass's horse, drove the doctor on house calls, and in general took care of Mrs. Douglass by answering the door and doing heavy work around the house. (Photograph by Joey Walker.)

Silver
Silver was Dr. John Douglass's dog. He is buried in the family plot next to his master at Mount Prospect Cemetery. Silver is the only canine in the cemetery. (Photograph by Joey Walker.)

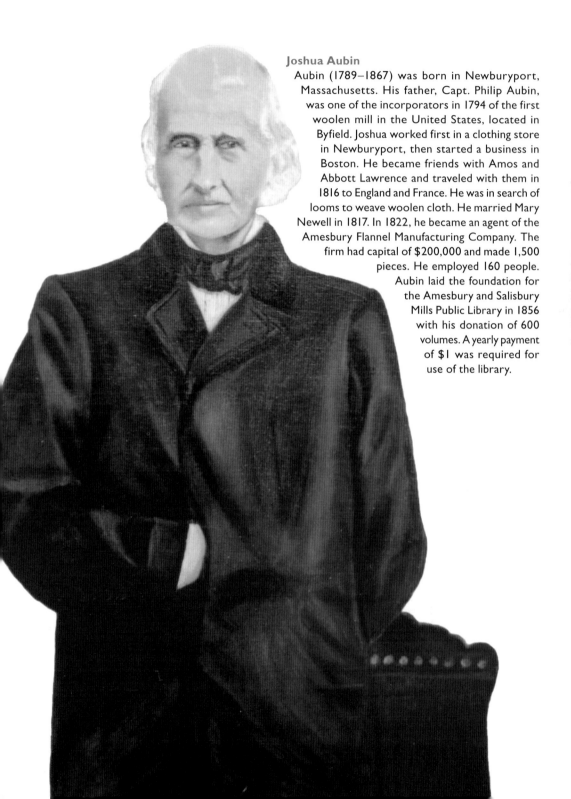

Joshua Aubin

Aubin (1789–1867) was born in Newburyport, Massachusetts. His father, Capt. Philip Aubin, was one of the incorporators in 1794 of the first woolen mill in the United States, located in Byfield. Joshua worked first in a clothing store in Newburyport, then started a business in Boston. He became friends with Amos and Abbott Lawrence and traveled with them in 1816 to England and France. He was in search of looms to weave woolen cloth. He married Mary Newell in 1817. In 1822, he became an agent of the Amesbury Flannel Manufacturing Company. The firm had capital of $200,000 and made 1,500 pieces. He employed 160 people. Aubin laid the foundation for the Amesbury and Salisbury Mills Public Library in 1856 with his donation of 600 volumes. A yearly payment of $1 was required for use of the library.

Benjamin Sawyer
Reverend Sawyer (1782–1871) presided at the Sandy Hill Meeting House (pictured) in Amesbury in 1814. In 1835, he went to the Rocky Hill Meeting House. His compensation there was $400 and the use of the parsonage. From 1835 to 1841, he presided over both the Sandy Hill and the Rocky Hill Meeting Houses, until Sandy Hill closed. In May 1859, he celebrated his 50th anniversary of being a preacher. On October 30, 1870, at 88 years old, Sawyer preached his last sermon. He officiated 1,400 marriages and 1,100 funerals in the course of his ministry.

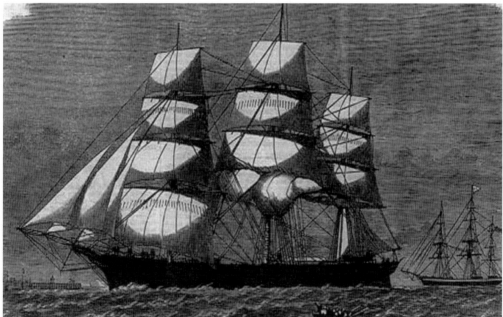

Augustus Follansbee
Follansbee was a captain who sailed from New York, around the world to China, then to England on cargo voyages. He was noted for swift passages, which he did three times. He was on the clipper ship *Greenfield* when it was lost in a fierce storm off the coast of Ireland in 1872. The ship was never recovered. (Photograph from Library of Congress.)

SUSANNAH MARTIN

HANGED

ULY 19, 1692

Susannah Martin

Martin (1621–1692) was accused and convicted of being a witch in 1692 during the Salem Witch Trials. She was the daughter of Richard North, one of the first settlers of Salisbury. In 1646, she married George Martin. She pled not guilty to the charges, but was hanged at the Salem gallows in 1692. She was posthumously pardoned by Gov. Jane Swift in 2001. (Photograph by Joey Walker.)

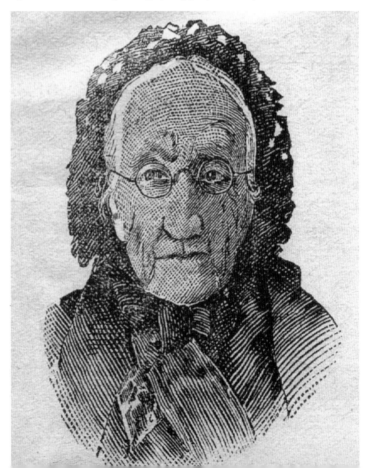

Polly Osgood
Osgood (1790–1890), the oldest woman in Amesbury, died 12 days after her 100th birthday. She had recollections of every president, remembered the death of Washington, and was present at the visit of Pres. James Monroe and General Lafayette to the town— she shook hands with both men. She married John Osgood, a ship caulker, and the couple had 11 children.

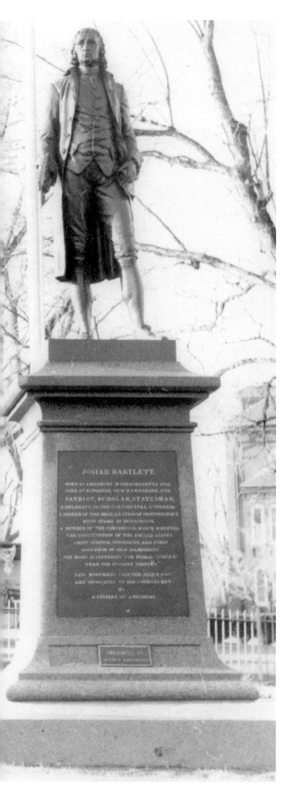

Josiah Bartlett

Bartlett was born in Amesbury in 1729. He was a descendant of Richard Bartlett, who came to Newbury in 1635. Josiah lacked a formal education, but he learned Latin and Greek from Rev. Samuel Webster. He moved to Kingston, New Hampshire, and started practicing medicine. Bartlett entered politics 15 years later, becoming a member of the legislature. He was one of the signers of the Declaration of Independence.

Thomas Sparhawk

Dr. Sparhawk (1806–1874) was born in Portsmouth, New Hampshire. He graduated from Dartmouth and received his medical degree from Harvard University. For 30 years, he was a physician in Amesbury. When patients contacted him, he would do everything he could to help them. On his gravestone is inscribed "To the Memory of our Beloved Physician."

Charles Stanley
Dr. Stanley was a physician in Amesbury. He set up a charitable organization, the Stanley Fund, through the Amesbury Public Library. The fund was established to provide money for outings and excursions for poor children of Amesbury. One of the fund's requirements was that the money be used for specific children and not all children. The fund is still used today.

Michael Walsh
Walsh (1763–1840) was born in Waterford, Ireland. He was the author of *The Mercantile Arithmetic* (1803). Walsh taught at four schools on Salisbury Point and had a full-time occupation. He also taught at the Marblehead Academy and at Latin Grammar School in Newburyport. He received a degree from Harvard. Walsh taught school in the basement of the home that he built, shown here.

George E. McNeil

McNeil started working in a carding room of the Salisbury and Amesbury Woolen Mill at the age of 10. He was working there when the great strike of 1851 took place. The boys went out with the rest of the men, and he organized them into a union with secret ceremonies. He went to Boston in 1856, a believer in organization with strong ideas about workers' rights. For nearly half a century, he was recognized as the foremost leader of organized labor in New England. In 1883, he organized the Massachusetts Mutual Accident Association. A man of strong character, he was ready to protect the oppressed against the oppressors. The McNeil Park is located at Friend and School Streets.

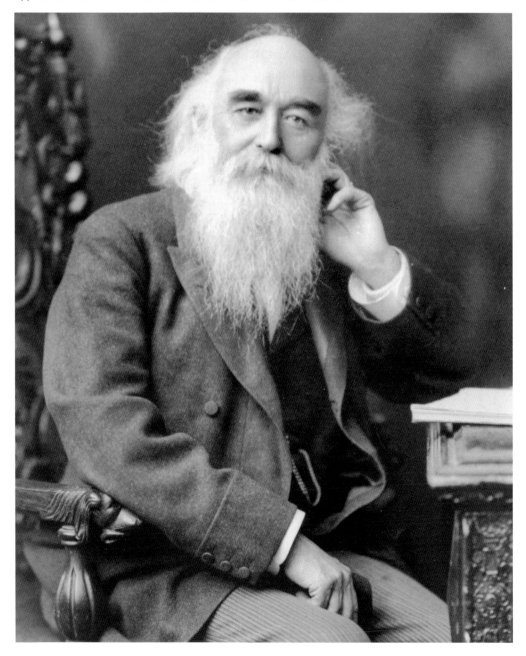

Thomas Wells
Wells was born in Ipswich in 1646 or 1647. In Amesbury in 1672, a committee was formed to attempt to bring Wells from Newbury, where he was preaching, to Amesbury to help with the ministry. For an annual salary of £40, Reverend Wells was the first pastor of Amesbury. He was chosen to record all births and burials. He served as pastor for 62 years.

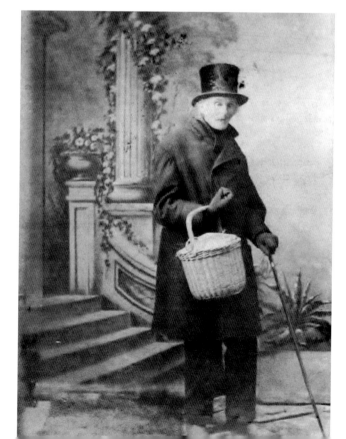

Deacon William Burbick
Burbick was an express man between Amesbury and Newburyport. He performed errands with his old horse and wagon for 15¢, specializing in facilitating mail service between the towns. If someone in Amesbury thought a letter was being held up in Newburyport, he would go over and pick it. The tall hat and egg basket seen here were characteristic of the deacon.

CHAPTER TWO

Business

They come in and buy their Cub Scout uniform, and then they come in and rent their prom tuxedo. Then they come back and get married and buy their tuxedo, and as they get older, they buy a suit. So there has been a lot of that over the years, just because this store has been here for so long.

—Ron Fuller, W.E. Fuller Company, Amesbury

Amesbury has been creating businesses since the incorporation of the town. Sawmills were built on the banks of the Powow River, and carriage manufacturing brought a huge boon to the community. People moved here from other countries and communities to work in the factories. Jacob Huntington was known as the "father of the carriage industry." Firms were established to manufacture accessories for the carriages. The automobile industry was also a major employer in Amesbury. The Bailey Company was a leading manufacturing company. Buffalo Peanut Butter was the brainchild of F.M. Hoyt. The W.E. Fuller Company was a downtown mainstay for 119 years. Fuller's closed its doors in July 2013. Cider Hill Farm provides farming opportunities to exchange students from 20 different countries. Hodgie's Ice Cream helps the community by donating to many organizations. Vermette's Market, in business since 1943, has changed on the outside, but the inside is still providing the same costumer service as when it opened. Amesbury has been leading the way for many years, building upon its successful past and providing opportunities for new businesses to come and begin their history.

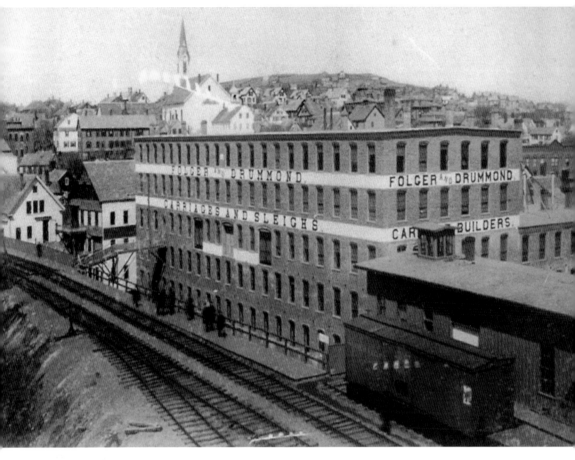

David J. Folger and James Drummond
Folger, born on Nantucket in 1869, worked for the Charles Patten Carriage Manufacturer. He succeeded the business upon Patten's retirement. In 1887, he joined forces with James Drummond, whose experience was in mechanics. Their firm, Folger and Drummond, was connected to the firm Goss, Drummond, and Company. Folger and Drummond made five types of heavy, closed-top buggies and 30 leading styles of pleasure carriages. Among the products were the two-seated surreys, Goddards, buggies, and side-bar road wagons on Timken springs.

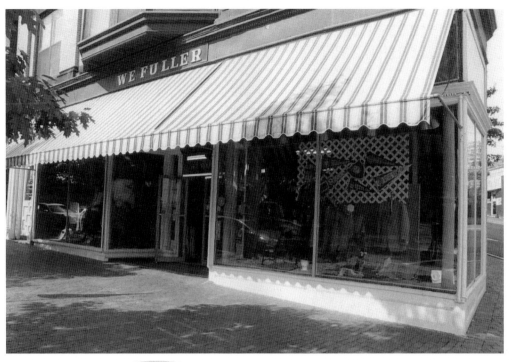

Ronald Fuller

W.E. Fuller opened its doors in 1894 and occupied the building shown here since 1901. Fuller was a member of the Besse-Foster System of 27 or more establishments doing retail business throughout New England. Success was made possible by huge purchases of merchandise at a savings. Ronald Fuller was the fourth generation of his family to run the store. The store closed its doors in July 2013. (Courtesy of Ronald Fuller; photograph by Margie Walker.)

Horace G. Hudson

Hudson was born in Enfield, New Hampshire, in 1846. He was a member of the Freemasonry, Warren Lodge, Trinity Royal Arch Chapter, and Amesbury Council. Hudson, a well-known jeweler in Amesbury, was considered a gentleman who was always ready to help his fellow man.

31

Jason Regis

Hodgie's was opened in April 1984 by Peter and Janet Hodge. Jason and Kelly Regis bought the business in 2006. The store makes its own award-winning ice cream in more than 40 flavors and also offers food. To accommodate customers with dietary restrictions, Hodgie's has sherbets, nondairy sorbets, and no-sugar-added ice cream. The store, which employs about 30 young adults from the community, donates to many local organizations. (Courtesy of Jason Regis; photograph by Joey Walker.)

Thomas W. Lane

Lane, one of the town's carriage builders, was born in Hampton, New Hampshire, in 1840. He moved to West Amesbury in 1861, and moved again, in 1865, to Lynn, where he worked as a blacksmith. In 1868, he started working for Jacob Huntington, then started his own business in 1874. The invention of the Lane Cross Spring in 1879 gave his business a boost and increased sales.

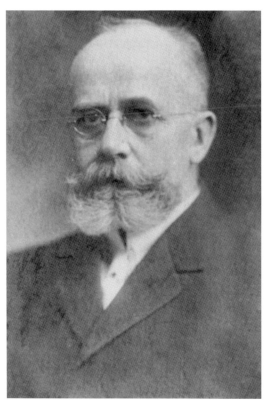

Frank A. Babcock
Babcock was a carriage manufacturer. He came to Amesbury in the 1870s from Connecticut. He began his own business, constructing a four-story brick building. His firm manufactured 5,000 carriages per year and employed 300 people. In April 1888, a fire in the Babcock factory quickly spread to other carriage-manufacturing companies and private dwellings. When it was over, 24 buildings were destroyed.

Samuel R. Bailey
The founder of the Bailey Company was 18 years old when he secured the warrant for the firm. He initially manufactured sleighs, which was a seasonal business in Maine. He then moved the company to Bath, Maine. Bailey registered patents for improvements to sleighs. The Bailey Whalebone Road Wagon was one of the finest in Amesbury. (Courtesy of the Local History Collection Amesbury Public Library.)

William Biddle
Biddle came to Amesbury in 1855 from Lowell to work at the Salisbury Mill manufacturing company for $5 per week. In 1870, he started manufacturing carriages. Biddle and Smart became one of the big four firms in the carriage industry. William Biddle was the largest stockholder of the Powow Water Company. He was actively involved with the gas company and banks.

William Smart
Smart learned his trade from George Larkin in 1861, at the age of 17. He was a painter of carriages for Larkin for one and a half years. He then went on to be a superintendent of painting for Jacob Huntington. He entered into a partnership with William Biddle in 1880, and Biddle and Smart was born.

Frederick W. Merrill
Merrill was born in Amesbury. He was a druggist for 47 years at 69 Main Street. He started as a clerk in the drugstore of D.L. Bartlett. After three years there, he worked for C.W. Merrill, whom he succeeded in business in 1867. Frederick Merrill was the treasurer and trustee of the Amesbury Public Library.

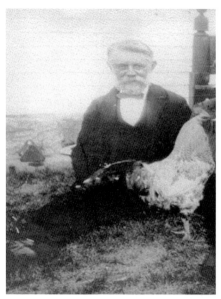

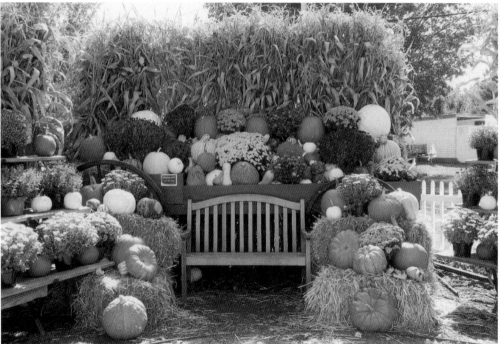

Cook Family and Cider Hill Farm
In 1978, Ed and Eleanor Cook purchased the old Battis farm. Their son Glenn and his wife, Karen, bought the Vedrani Poultry Farm and, with the other couple, joined efforts. Glenn is a member of the Essex County Farm Bureau Board of Directors. Karen is a trustee for the Essex County Agricultural Society and a former Mrs. Essex County. The Cooks offer opportunities for teens from other countries to come and work at their farm. They are actively involved in Amesbury, donating to many organizations. Eleanor passed away in 2012. She could always be seen working in the fields. This Cider Hill Farm fall display shows mums, gourds, and pumpkins for sale (Photograph by Margie Walker.)

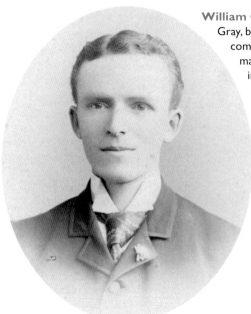

William C. Gray

Gray, born in Washington, DC, was associated with a textile company that supplied carriage seat covers. He started manufacturing oil lamps for carriages with J. Albert Davis in Amesbury. During World War I, Gray converted his plant to the production of shells and detonators for the government. He was active in the Wonnesquam Boat Club and the Warren Lodge.

J. Albert Davis

Davis was a manufacturer of carriages and automobiles. He was partnered with William C. Gray in the Gray and Davis Lamp Company (pictured). Davis was very interested in the Amesbury Library and was elected to the trustees in 1909. A musician, he played brass, woodwind, and stringed instruments. He was a member of the Allepo Shrine of Boston and the Amesbury band.

George W. Osgood
Osgood began his carriage business in 1870, which increased and eventually stretched to the Atlantic and Pacific shores of the United States. He also had a production market in foreign countries. He was a prominent person in town and a member of the board of trade. His factory consisted of 10 buildings, from one to three stories tall, covering an area of two acres. Most of the parts were made here. The company's 55 employees made 700 carriages of all varieties as well as sleighs. Among the firm's departments were woodwork, trimming, a paint shop, and ironworks.

GEORGE W. OSGOOD,

MANUFACTURER OF, AND DEALER IN FINE

Victorias, Surreys, Rockaways, Phaetons,
Extension-top Cabriolets, Goddards,

AND ALL STYLES OF LIGHT BUGGIES,

——— ALSO SPECIALTIES IN ———

Depot, Game, Kensington, and Derby Wagons,

IN NATURAL WOOD.

CATALOGUES FURNISHED ON APPLICATION.

FACTORY: REPOSITORY:

Powow Street. Carriage Hill, Cor. Chestnut St.

AMESBURY, MASS.

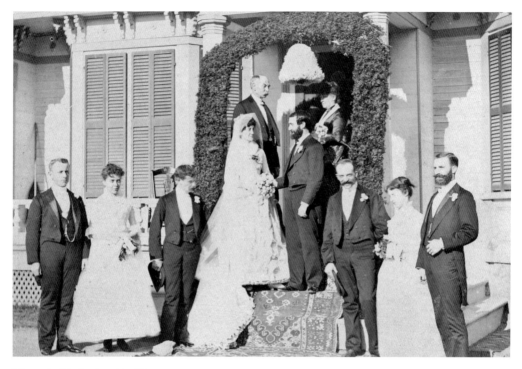

Marquis De Lafayette Steere
Steere (standing top left, under the arch) started work in a woolen mill when he was a young boy, making $8 per week. In 1858, he took charge of the Salisbury Woolen Mill. He became a silent partner with Biddle and Smart, the largest company at the time. He was one of the planners of the Powow Water Company and he organized the Amesbury & Salisbury Gas Company. He brought the opera house to town.

Richard Currier
Born in England about 1616, Currier was one of the early settlers of Salisbury. He received land in 1641–1643 and worked as a planter and millwright. He and Thomas Macy were authorized to build a sawmill, which was built along the Powow River. He was one of the prominent men of New Town (Amesbury), owned a lot of real estate, and was the second town clerk. Currier was a soldier in the Narragansett War.

38

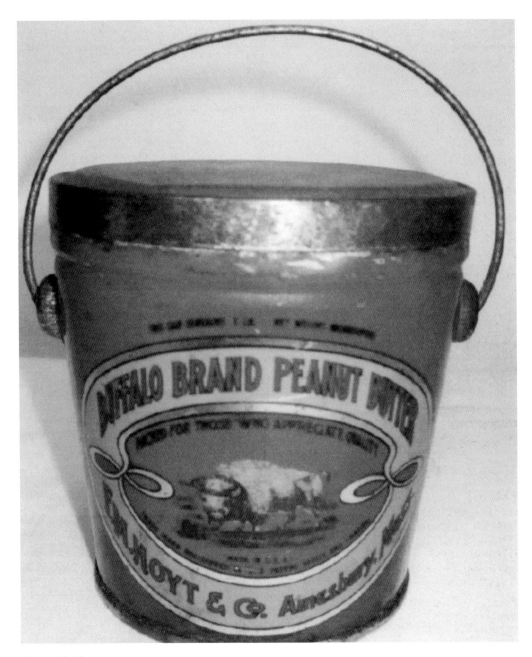

Frank M. Hoyt
Hoyt (1871–1965) started his business at his home on Greenwood Street. He made peanut butter and chew taffy, and the Buffalo Brand were born. Expansion came quick as news spread of his delicious offerings. In 1914, he bought a large factory building on Oakland Street. Peanut "But-A-Kisses" were the result of Hoyt's own taste and imagination. During World War II, he shipped a massive amount of kisses to the troops. As president of the chamber of commerce, his goal was to attract more businesses to Amesbury. He gave a substantial amount of money to the Amesbury High School Scholarship Fund, which gives two or three $100 awards to the graduating class. He also gave to the Home for Aged Women of Salisbury and Amesbury.

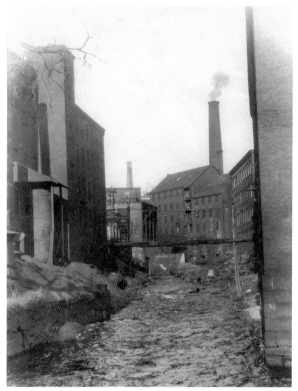

Jacob Perkins
Perkins was born in Newburyport in 1766. When he was 12, his family sent him to a goldsmith to learn a trade. He had an inventive mind, and he experimented, creating a nail-cutting machine. He established the Amesbury Nail Manufacturing Company to produce a headed nail or tack. The factory (shown here) was located on the falls of the Powow.

Elbridge S. Feltch
Feltch was born in Kensington, New Hampshire, in 1828. He was interested in the Town Improvement Society and was one of the original directors of the Powow River Bank. Feltch's Carriage Company flourished, and by 1891, he had seven buildings. He employed 70 workers and produced 1,000 carriages annually. The firm's Rockaways and two-seated canopy wagons were of the finest quality. He died in 1903.

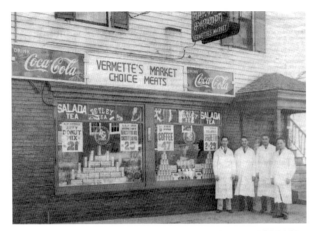

Vermette's Market
Vermette's Market was established in 1943 by Edward J. Vermette and his wife, Mabel. They both enjoyed working at the store and interacting with their customers. The store has expanded to keep up with the demand. Today, Vermette's is owned by Edward's daughter Elaine and her husband, Donald Fowler. It offers groceries, meats, dairy, and produce. (Courtesy of Elaine Fowler.)

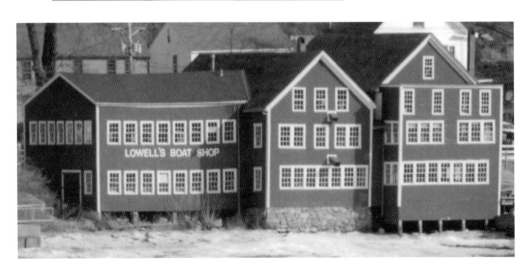

Simeon Lowell, Lowell's Boat Shop
Lowell was responsible for redesigning the hard-to-handle wherry, and the dory was created in 1793. Lowell's Boat Shop has been in operation since 1793, and seven generations have run the business. The shop is small but focuses on craftsmanship rather than high-quantity output. The shop continues to build dories today, and it offers educational programs for people of all ages. (Photograph by Joey Walker.)

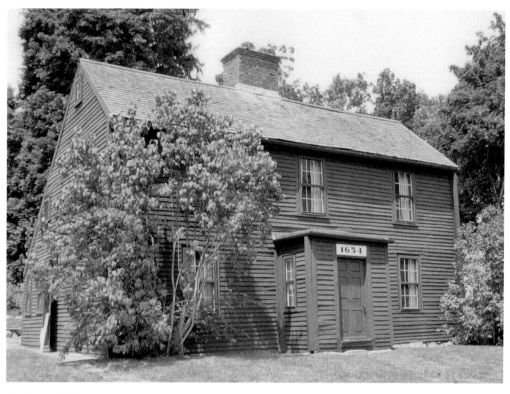

Anthony Colby
Colby was born in Horbling, England, in 1605. He was an original settler of Salisbury and was one of 69 men to receive first division lots in 1639. He moved across the Powow River to the future New Town (Amesbury) with other families. Anthony's home is pictured. The articles of agreement, which designated the rights of its inhabitants, were signed in 1658. (Courtesy of Macy Colby House.)

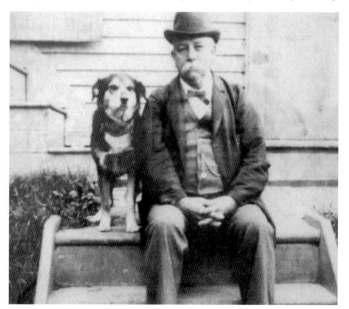

Moses Long Colby
Colby was born in Amesbury in 1822, the youngest child of Capt. William and Mary Long Colby. He was educated in Amesbury and went to Boston to learn the trade of boot-making. He belonged to the Boston Fire Company. In 1849, he went to California in search of gold, returning to Amesbury years later. Colby never married. He sold the Macy Colby house to the Bartlett Cemetery Association. (Courtesy of Macy Colby House.)

CHAPTER THREE

Culture

Whatever that thing is in your head and heart that you think about when no one else is around and you think that would be so cool if only I could do that? You can do that! Your hidden desires are very important and you need to listen to your heart and go for it. Life is short and work is hard, so you might as well work doing something that you love.

—Greg Hoyt

Amesbury has been home to artists, poets, writers, historians, and fashion designers. The people in this chapter weren't known just locally, but worldwide. They went on to have their work displayed and sold in museums, libraries, and stores across the world. Sports have always been important to the residents, and statistics for all of the sports have been recorded from the early days. Amesbury coaches have brought new meaning to teamwork by encouraging the players to work together. Television and movies are also part of the town, as local actors have appeared on the big and little screens. Local historians have documented Amesbury history through the years in print, manuscripts, and paintings. They helped to keep history alive and accessible to people conducting research and those curious about the past. Without their groundwork and documentation, it would have been difficult to access all of the information for this book. Children and teens will continue to do great things to make the world a better place. And they will all have one thing in common: they called Amesbury home.

Robert Frost

Frost was born in San Francisco in 1874. He moved to Lawrence, Massachusetts, when he was a child. He attended Dartmouth University for several months and returned home in 1894 and succeeded in writing his first poem. He went on to write many poems about rural life. Frost summered in this home on Point Shore.

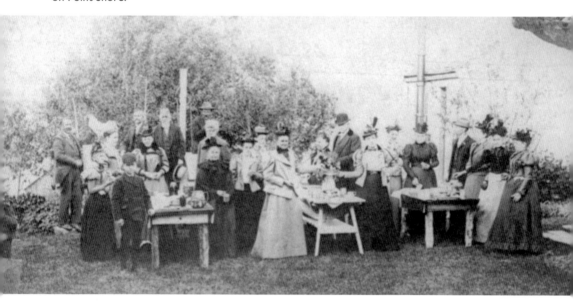

Pleasant Valley Literary and Social Society

An annual picnic brought the members of this society together. The gathering shown here took place in 1898. The following members were in attendance: Newell Huntington, Mrs. Warren Huntington, May Warren Goodwin, Gus Goodwin, Warren Goodwin, J. Warren Huntington, William Worthen, Rebecca Goodwin, Annie Bowden, Ida Davis Jones, Mrs. Gus Goodwin, Mrs. William Goodwin, Annie Worthen, Jane Davis, Eliza Davis, Anna Davis and Mrs. Charles Rowell. The ladies of the group were also members of the Female Charitable Society, which helped those in the community who were in need of food and clothing.

Alfred Gerald Caplin
The cartoonist Al Capp (1909–1979) was born in New Haven, Connecticut. With the Li'l Abner cartoon series, he created a day-to-day adventure of a family in an isolated town. As well as being a draftsman, Capp was also a narrator and a creator of myths, fables, and legends. Sadie Hawkins Day is still observed on many college campuses today. (Courtesy of Julie Capp Cairol.)

Jon P. Mooers
Mooers was born in Amesbury and went to Amesbury schools. He graduated from the University of New Hampshire and worked at Universal Studios as a scenic artist. He was hired for 19 feature films as a set dresser, scenic artist, and special effects artist. He has created more than 150 murals all over New England and Southern California, including several in Amesbury. (Courtesy of Jon P. Mooers; photograph by Joey Walker.)

Charles H. Davis

Davis was born in Amesbury in 1856. At the age of 15, he left school to work in a carriage factory. He began to draw charcoal sketches and studied at the Museum of Fine Arts Art School in Boston. He studied for two years under the artist Emil Otto Grundman. Jacob Huntington became interested in Davis and offered to lend him $1,000 to study art in Paris. In 1882, Davis offered a landscape to the Paris Salon, where it was accepted. He remained in France for 10 years. Davis donated *Avril* (shown here) plus other paintings to the Amesbury Public Library. His paintings are in the Metropolitan Museum of Art in New York, the St. Louis Art Museum, the Art Institute of Chicago, and the Museum of Fine Arts in Boston.

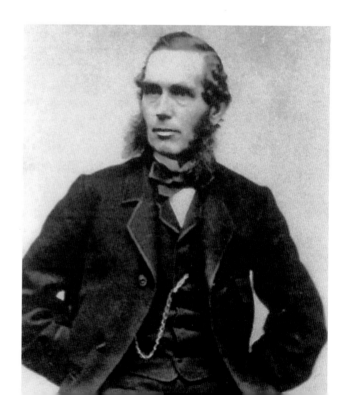

Nathaniel Currier

Currier (1813–1888) was part of the famous printmaking firm Currier and Ives. He had been producing lithographs on his own before he partnered with James Ives. He painted quaint scenes of family and community. Currier loved to spend time with his wife at their farm on Lions Mouth Road. He would travel around the Lions Mouth, Whitehall Road, and South Hampton areas.

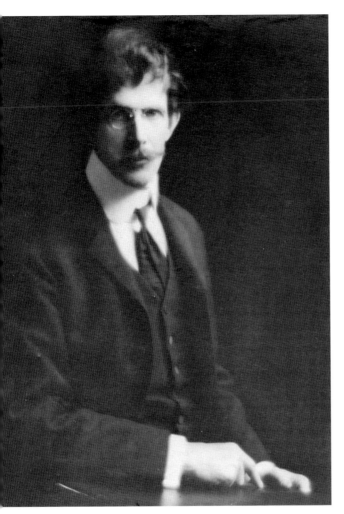

Ralph Clarkson

Clarkson (1861–1942) was born in Amesbury and educated at Amesbury High School. He went on to study at the School of the Museum of Fine Arts in Boston, he enrolled at the Julian Academy in Paris. Clarkson taught painting at the School of the Art Institute of Chicago and was president of the Chicago Society of Artists.

Samuel Rowell

Rowell (1815–1890) was an Amesbury-born artist and a carriage manufacturer. He was remembered more for his paintings than his carriages, which he shipped all over the United States. He was able to trace his Quaker lineage through the records of generations of Amesbury Monthly Meeting of Friends to Valentine Rowell and Robert Jones, pioneer settlers. Samuel Rowell began his career going from town to town, looking for employment.

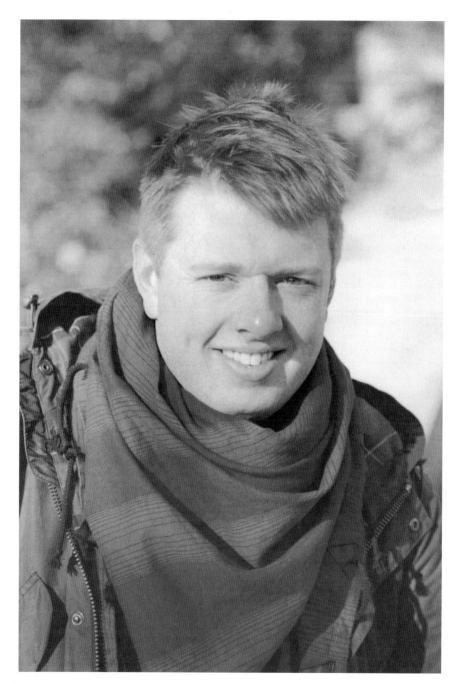

Ryan Noon
Noon was born in Amesbury and went to Amesbury schools. When he was at Amesbury High School, he started his own successful line of clothing. He credits his aunts and family with helping in his pursuits of design. He had several fashion shows in Amesbury and the surrounding communities. Noon is a graduate of St. Martin's College of Art and Design in London, and he showed his own line at London Fashion Week. He is an apparel print and pattern designer in global women's training for Nike, for whom he has traveled extensively in Europe and Asia. (Courtesy of Ryan Noon; photograph by Joey Walker.)

Wilfred R. Cyr
Cyr (1889–1953) was born in Amesbury. Though physically disabled, he made use of his head, neck, wrists, hands, and ankles. His disability did not stop him from becoming an artist. He liked to paint familiar portraits and local scenes.

Horace Philip Giles
Giles was born in Amesbury and lived in Merrimacport for many years. He was a portrait and landscape artist. The farmhouse in this picture was torn down in the 1930s. His family donated the painting to the Amesbury Public Library. It was given in memory of his mother.

John Greenleaf Whittier

Whittier (1807–1892), born in Haverhill, Massachusetts, is known as the "Quaker Poet." He was an abolitionist, statesman, patriot, and poet. He will always be remembered by his winter poem *Snow-Bound*. Whittier was a trustee of the Amesbury Public Library. When he passed away, much of his own personal collection was donated to the library, including many letters and personal papers. In 1905, he was honored by having his name placed in the Hall of Fame at Bronx Community College.

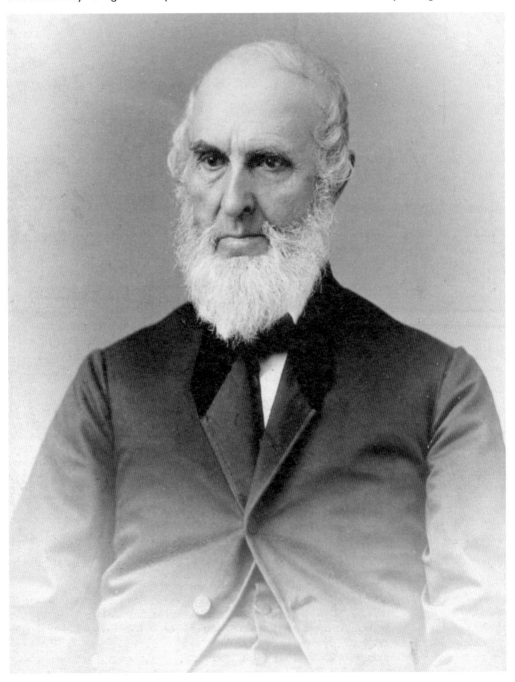

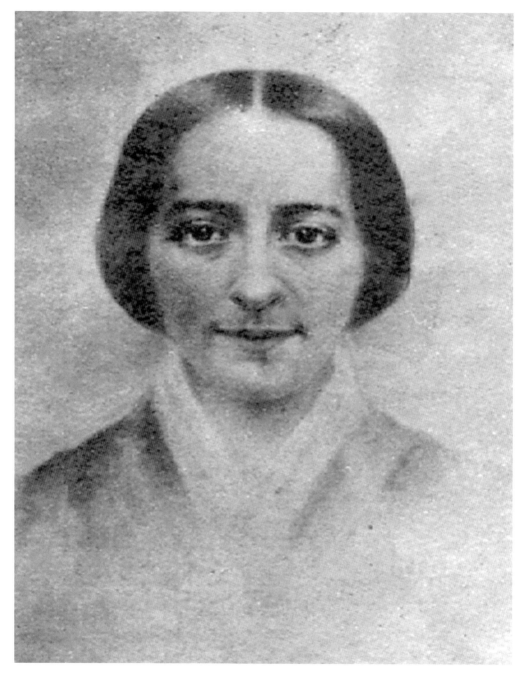

Elizabeth Whittier
Whittier is the younger sister of John Greenleaf Whittier. She moved to Amesbury when she was 20 years old and lived with her mother and aunt in a cottage, with limited means. She worked with the abolitionist movement as a member of the Amesbury and Salisbury Female Anti-Slavery Society and the New England Anti-Slavery Society. She wrote powerful poetry about the movement. She shared her brother's interest in abolitionist reform, assisting him by performing clerical duties. She became president of the Women's Anti-Slavery Society.

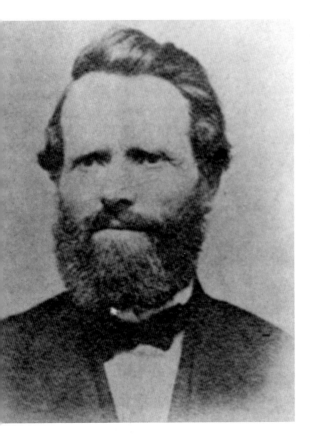

Joseph Merrill
Merrill (1814–1898) was born in Amesbury. A reluctant farmer, he went to Boston in 1835 to learn the hatter's trade. He received $9 for 72 hours of work. Merrill had a profitable shoemaking business. He became a teacher at Pond Hills School, where he introduced singing. He wrote the book *History of Amesbury* in 1880. He was town clerk from 1844 to 1880.

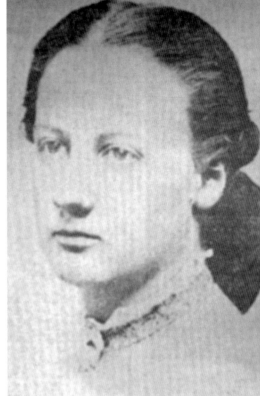

Frances Campbell Sparhawk
Sparhawk was born in Amesbury and attended private school. The first book she wrote was for young readers, about Abraham Lincoln. She then wrote a series of Dorothy Brooke books. Sparhawk loved writing, but she never tried poetry, even though John Greenleaf Whittier was a major influence in her life. She was interested in Native Americans and spent time at the Carlisle Indian School in Carlisle, Pennsylvania.

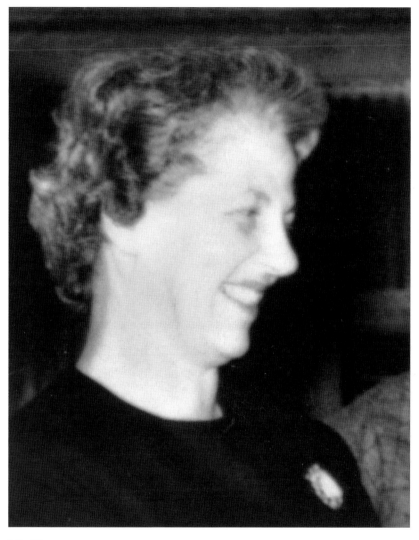

Margaret S. Rice
Rice was born in 1906 and graduated from Amesbury High School in 1924. She received bachelor's and master's degrees from the University of Vermont. She was a member of the history committee and the historical commission and was the president and secretary for the Carriage Museum and Bartlett Museum. She gave tours of the Macy Colby House and was a member of the Amesbury Improvement Association. Rice was editor for the *Bailey Bea* for the Bailey Company. She managed the 1690 House of Towle Manufacturing. In 1973, she joined the staff of the Amesbury Public Library. She offered research services free of charge to anyone interested in their family history. She published several books, including the following: *Sun on the River*, about the Bailey Company; *On These Things Founded*, about Salisbury's history; and *Brief History of the Carriage Industry*. She gave her time and energy to every historic and cultural group in Amesbury.

Harriett Prescott Spofford
Spofford (1835–1921) was born in Calais, Maine. She moved to Newburyport when she was young and graduated from Putnam Free School. While there, she won a prize for an essay on Hamlet. The essay attracted the attention of well-known author Col. Thomas Wentworth Higgins, who became a friend and offered encouragement. Spofford was first published in *Atlantic Monthly* magazine, and she went on to write 18 books as well as poems. Considered one of the best literary women of her time, Spofford was instrumental in the evolution of the short story. She married Richard S. Spofford, a lawyer, in 1865. They resided on Deer Island in Amesbury.

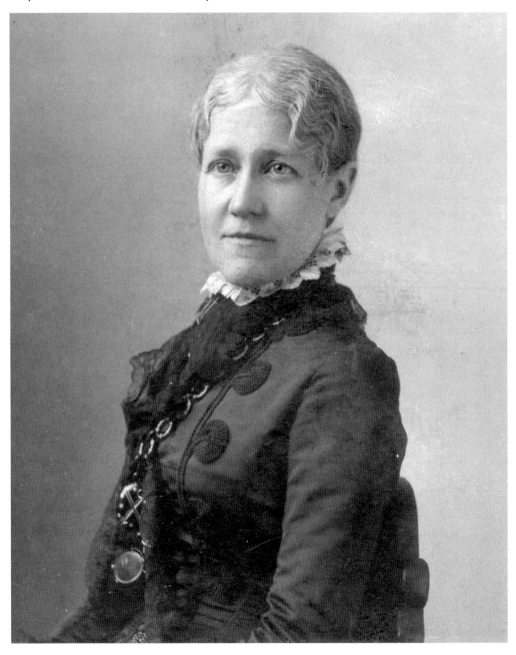

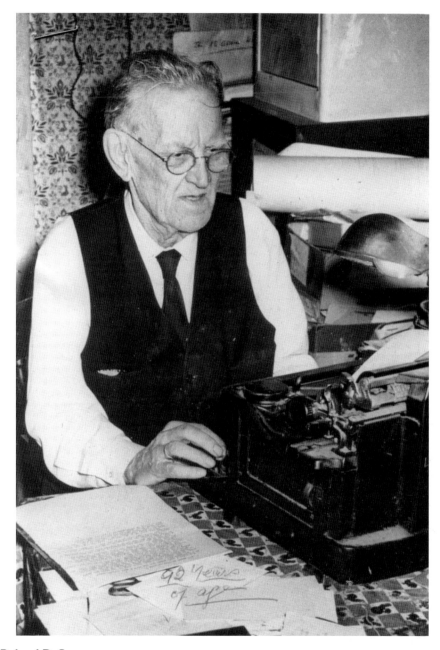

Rev. Roland D. Sawyer
Reverend Sawyer (1874–1969) was born in Kensington, New Hampshire. He never lived in Amesbury, but he felt a close connection to the city. He started coming to Amesbury between 1880 and 1883 with his father. He would see the horse cars pull in from Newburyport over what in trolley time was known as the Citizen Line. When he was 10, he came with some of the farmers to sell produce. Sawyer served in the Massachusetts House of Representatives for 27 years and was a minister at the Ware Congregational Church. Later, he learned that his grandmother, a Currier, lived on Lions Mouth Road. He started doing research at the Amesbury Public Library to find out about his family. He began to write short stories, published in the *Amesbury News*, about Amesbury and Salisbury.

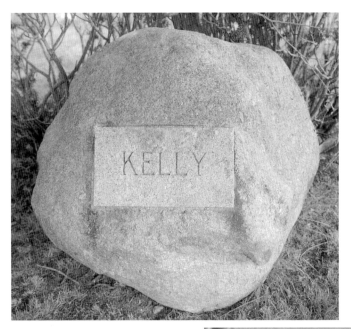

Eric Kelly
Kelly graduated from Amesbury High School in 1902, then went on to Dartmouth College. He was a reporter for the *Boston Herald* and *Springfield Republican* and taught journalism at Dartmouth. Kelly won the Newbery Medal for *The Trumpeter of Krakow*, written in 1929. During World War I, he was decorated by the Polish government for service in that country as a representative of the American YMCA. (Photograph by Joey Walker.)

Edward "Ted" Trombla
Trombla's book *The Best of Trombla* is an outstanding collection of columns that he wrote for the *Amesbury News*. He served on the school committee and on the boards of the Provident Bank and the Rotary Club, and was an assessor and an Amesbury Library trustee. Trombla (1897–1985) was a member of the Gardeners' and Florist Club of Boston, where he won top prize for his chrysanthemums. He was published in *Yankee* magazine, *Modern Maturity*, and other publications.

Edward "Ned" Brown
Brown (1906–1980) spent most of his life working for the *Newburyport Daily News*. He became manager of the Amesbury bureau of the paper, then later became editor. He devoted 52 years to the paper. He was noted for his "Cabbages and Kings" column, providing history and observations about the community. It is believed that it was the longest-running column in the United States. He was elected in 1913 as an Amesbury Library trustee and spent 25 years on the board.

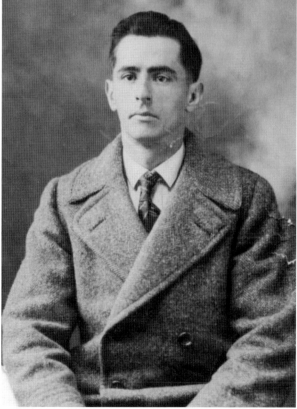

John F. Kellett
Kellett (1897–1983), a local historian, wrote many articles for the *Newburyport Daily News*. He wrote several manuscripts on places, people, and groups related to Amesbury. He sent his work to the Amesbury History Committee, which placed them in the Amesbury Public Library. There are 52 manuscripts in the local history collection.

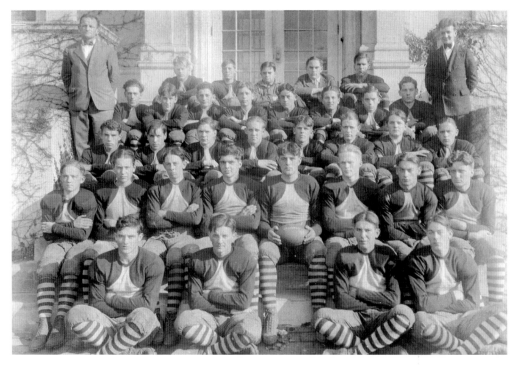

1927 Amesbury High School Football Squad
Senior Martin Mailet rose to the occasion, leading the Amesbury football team to its first undefeated and untied regular season. They did lose their postseason game, however. Mailet and John McGrath gained a reputation for being the best linemen in the history of Amesbury football. Pictured here are, from left to right: (first row) Norman Felch, Joseph Joubert, Edward Ouellette, and Stanley Gordon; (second row) Orvo Suorsa, Robert Davidson, John McGrath, Eugene Richardson, Martin Mailet (captain), William Clark, John Brady, and Elmore Boyle; (third row) Fred Merrill, James Currier, Edwin "Ned" Mudge, Olave Wiitanen, Robert Pike, Kenneth Scott, Tubby Randall, and Alfonz Wallace; (fourth row) George Tuxbury, Walter McGlinn, Paul Shoreman, Robert Vieter, Grant Morse, Pat Polletta, Arthur Copplestone, and John Reddy; (fifth row) Charles Broderick (coach), Maurice Currier, Erwin Pike, Randall Jennings, Kilby Marble, Herman Currier, and Malcolm Breonas (assistant coach).

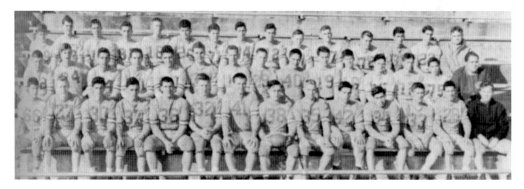

1951 Amesbury High School Football Team
On Thanksgiving Day, the big game against rival Newburyport took place. Excitement was in the air, but no one expected the game of the century, with 15 players sharing in the scoring. It was truly a team effort, as Amesbury defeated Newburyport 99-6.

Harold "Bert" Spofford
Spofford was born in Georgetown, Massachusetts, in 1917. He graduated from Cornell University with a bachelor's degree in economics and physical education. He was in the US Army in 1942 as a private and was discharged as a captain in 1946. He served in the active reserves in many positions. He retired in June 1970 as lieutenant colonel. Bert loved sports and had a long career in football, basketball, and baseball. In 1935, at Sanborn Prep School, he had 81 strikeouts and limited opponents to five runs. He was considered an outstanding semi-pro pitcher. Spofford coached the Amesbury/Newburyport Merchants in the former Northeast Baseball League and was a varsity baseball coach at Amesbury High School and a volunteer assistant coach. When his coaching days were over, he could still be seen on the sidelines in his lawn chair, watching a game. He worked for 15 years as the Amesbury Park and Recreation director. He was also named by the chamber of commerce as Amesbury Man of the Year for his contributions to the community. Spofford spent countless hours going through old newspapers on microfilm, recording sports statistics for baseball, basketball, football, and hockey. The books he completed are at the Amesbury Library. Bert and his wife, Doris, loved to go ballroom dancing. (Photograph by Aleta Estabrook.)

Anthony Tassinari

Tassinari was the highly successful coach of the Amesbury High School football team. He produced nine winning seasons, had only two losing seasons, and had a .500 year. Amesbury High School won five Northeastern Conference championships and, in 1952, the Class C title. He inspired loyalty in his boys and helped them reach unbelievable levels of success. Tassinari was always available to his players, spending hours and nights helping any student he could. He suffered a fatal heart attack only hours after the 1955 Thanksgiving Day game. It stunned the community that such a great man could be gone. He came from Salem and graduated from Salem High School and Boston College. In 1986, he was inducted into the Massachusetts High School Football Coaches Hall of Fame. Tassinari will be enshrined on the campus of Boston College.

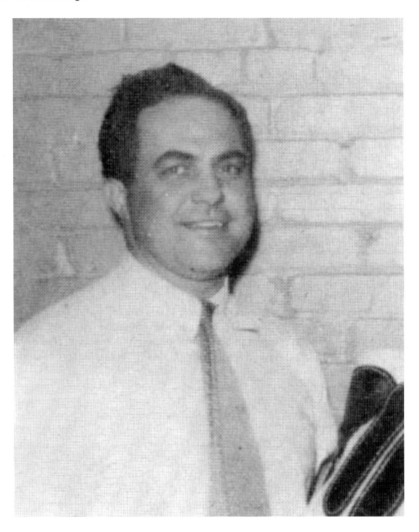

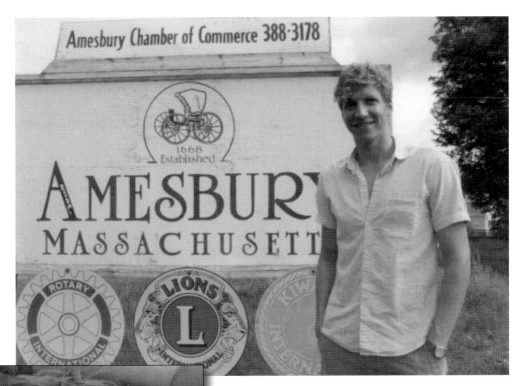

Gregory Hoyt

Hoyt was born in Amesbury and went to Amesbury schools. He graduated from the University of Massachusetts with a bachelor of arts degree in theater. He got started in acting when his mother needed a younger person to appear in a high school play. He really got the bug when, while laid up after being hit by a car, he watched *Lord of the Flies*. His parents encouraged him and his sister to follow their dreams. His big break came after he appeared in a film for the Women's Crisis Center. Suzanne Dubus, who filmed the antiviolence documentary, and his mom, Patty, were his mentors. He was happy to become a member of the Screen Actors Guild and the American Federation of Television and Radio Artists. He has been in several commercials, the movie *J. Edgar*, and many television series. In *J. Edgar*, he was directed by Clint Eastwood and was able to work with Jeffrey Donovan, another Amesbury High School drama club graduate. He has been in more than 300 improvisation shows in the Los Angeles area. Hoyt has created a family of people who have different talents and all work together to support one another. (Courtesy of Greg Hoyt; above photograph by Margie Walker; left photograph by Greg Hoyt.)

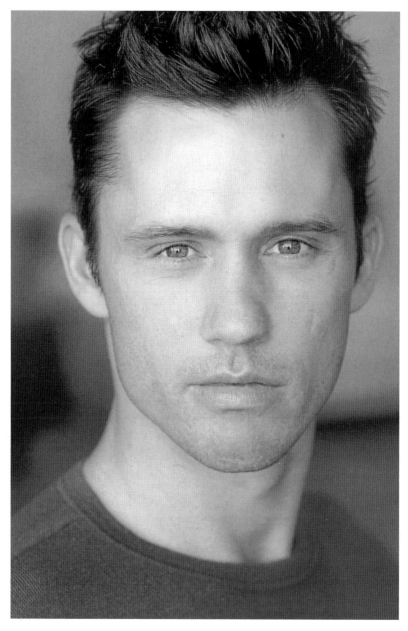

Jeffrey Donovan

Donovan was a hometown boy who had dreams of making it big. Well, dreams do come true. He is the star of the hit television series *Burn Notice*. He was very active in the drama club at Amesbury High School, and he credits the school's drama director, Patty Hoyt, for his success. He graduated in 1986, then went on to Bridgewater State College and graduated from the University of Massachusetts Amherst. Donovan received a bachelor of arts degree in theater, then went on to earn his master of fine arts degree from New York University's graduate acting program at the Tisch School of the Arts. He was in Clint Eastwood's movie *J. Edgar* with Amesbury's Greg Hoyt. He has been in dozens of television series and many movies. Donovan set up a scholarship fund at Amesbury High School through the Amesbury Educational Foundation. (Courtesy of Jeffrey Donovan.)

Johanna Hoyt Kimball

Kimball was born in Amesbury and attended Amesbury schools. She graduated from the University of New Hampshire and received a master's degree from the New England Conservatory of Music. For many years, she has performed as a singer in the Boston area as a soloist, in musical theater, and in classical music concerts. She shares her love of music with people of all ages. She teaches at the Musical Suite in Newburyport and at the Cashman School in Amesbury. Kimball was an Amesbury Library Trustee for many years. She is married to municipal councilor Derek Kimball, and they have three children. (Courtesy of Johanna Hoyt Kimball; photograph by Joey Walker.)

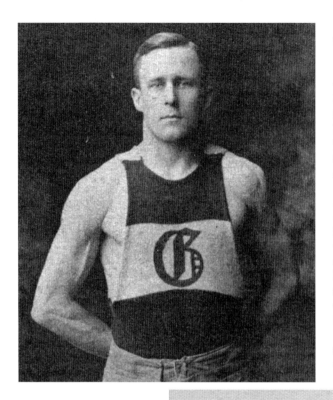

Somersby C. "Sam" Follansbee Follansbee moved to Amesbury when he married. He was involved in sports and became a professional baseball player. He also played basketball, earning a place in the Basketball Hall of Fame in Springfield. He was instrumental in establishing, in 1919, the annual tradition of high school football banquets. Follansbee and the school superintendent and high school principal rolled up their sleeves and served the first dinner for the players.

Charlotte T. Bailey Bailey (1860–1938) graduated from the New England Conservatory of Music. She taught in Amesbury for many years and was a pianist, contributing to programs at many concerts and at meetings of the Amesbury Music Club. She was a student at Cowle's Art School and was a pupil of the late Charles Davis. Bailey was a member of the Copley Art Society.

PIANO RECITAL

BY PUPILS OF

Miss C. T. BAILEY;

ASSISTED BY

Miss ALICE CHILDS, Violin.

● THURSDAY, ● APRIL 5, ●

1888.

CHAPTER FOUR

Military

Crossing a small lot with a few scattered cars and trash piles, a pack of four or five dogs picked up our scent and barked to alert the area to our presence. We held up at the far side of the lot, less than a hundred meters from the Iraqi Police station. A group of kids had been playing around in the street, but had scattered as soon as we left the station. In previous years, that was a bad sign. Kids scattered and plugged their ears before roadside bombs detonated in the streets of Iraq.

—Jordan Shay, Iraq

Amesbury men and women have been involved in many wars. Memorials have been erected in the city to honor the veterans who have served. Lives were lost, many at a very young age. Men fought in the Revolutionary War, King Phillip's War, and the Civil War. Alanson St. Clair Currier was held prisoner at Libby Prison in North Carolina. Myles Moylan fought at Gettysburg and Little Big Horn. Thornton Square is named after John Thornton, who lost his life during World War I. Landry Stadium is named after James Landry, who was killed in World War II. Jordan Shay lost his life in the war in Iraq. The VFW Post 2016 carries on the tradition of organizing ceremonies on Memorial Day. Wreaths are placed in Union Cemetery, Polish Memorial, William Justin Memorial, Veterans Memorial, and at the E.P. Wallace VFW post. A wreath is thrown in the Merrimack River at Alliance Park for fallen soldiers. Parades on Veterans Day and Memorial Day honor past and present soldiers. Amesbury men and women went off to war to protect the freedom that citizens have today. Amesbury has true heroes walking among it. They are to be honored and remembered.

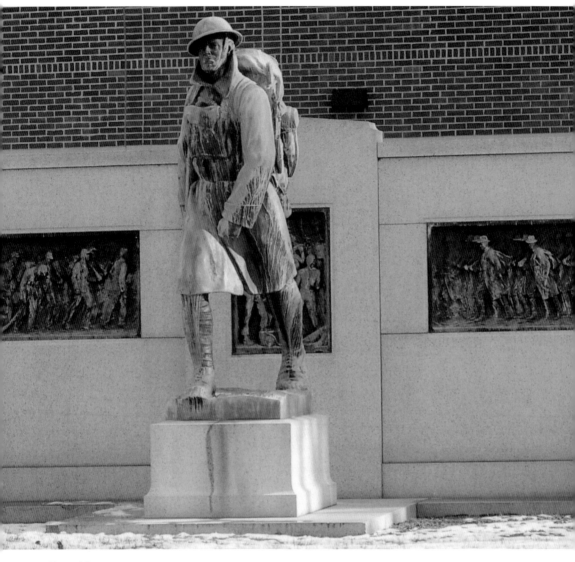

Doughboy

The *Doughboy* was dedicated on November 11, 1929. Gov. Frank Allen was a guest speaker at the dedication. The memorial to military personnel was designed by Leonard Craske. The plaques represent the Revolutionary War, War of 1812, and the Civil War. The *Doughboy* is located on the lawn at the Amesbury Middle School. (Photograph by Joey Walker.)

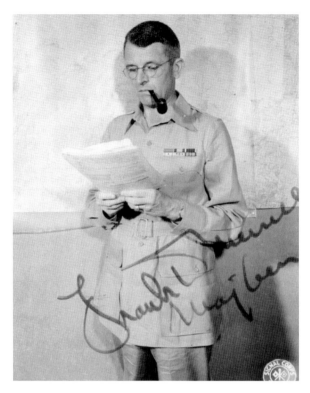

Frank D. Merrill
Brig. Gen. Frank Merrill headed the rough-and-tough volunteer outfit known as "Merrill's Raiders," which, with other American units, pinned 2,000 Japanese soldiers in a triangular trap in northern Burma during World War II. He graduated from Amesbury High School in 1921.

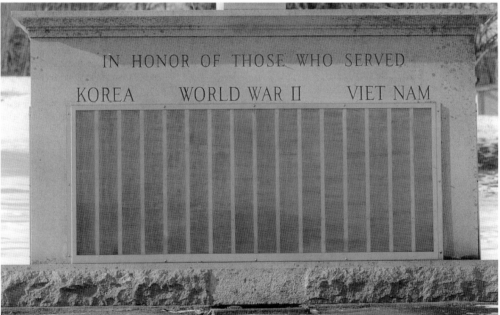

Veteran Memorial
The Veteran Memorial includes the names of all of the soldiers who served in World War II, Korea, and Vietnam. The monument is located on Main Street across from Amesbury Middle School. (Photograph by Joey Walker.)

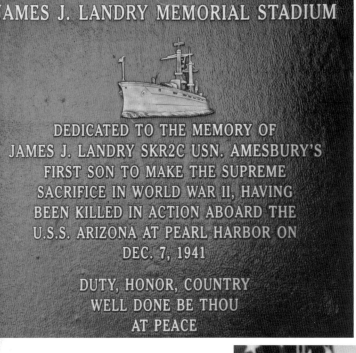

James Landry
Landry (1920–1941) was a seaman, first class, on the USS *Arizona* when it was sunk in the Japanese assault on Pearl Harbor on December 7, 1941. He was Amesbury's first casualty of World War II. Landry was in the Navy for several years. His name is listed on the Arizona Memorial. At a special town meeting, it was unanimously decided to name the proposed stadium after him. (Photograph by Joey Walker.)

June Knox
Knox, who served in the Navy from 1943 to 1945, was stationed at Norfolk, Virginia. She was a pharmacist mate. She has said that being in the Navy was the best thing that ever happened to her. She met some great friends with whom she still corresponds, and she was able to get an education. Her husband was also in the Navy. (Courtesy of June Knox.)

Sally Lavery
Lavery (right) was born in Newburyport, Massachusetts, and attended Newburyport schools. She studied hotel administration in college, then joined the Navy. Lavery moved to Amesbury and became a member of the Carriage Museum, Whittier Home, Friend of the Amesbury Library, and many other committees. She is a direct descendant of William Osgood, one of the early settlers of Amesbury, and Alanson Currier. (Courtesy of Sally Lavery.)

Jordan Shay (BELOW AND OPPOSITE PAGE)
Shay was born in 1987 and graduated from Amesbury High School in 2005. He was a specialist in the US Army, eventually promoted to the rank of sergeant. Shay was serving his second tour of duty in Baqubah, Iraq, when he was killed in 2009. He had left his mom, Holly, a "just in case" letter. He wanted her to take care of his fiancée, Kelsey, and his dog, Nora. He also wanted her to establish a scholarship fund—a big one—for someone who was going into a service profession. Shay loved life. He worked at the Salisbury Reservation, and a memorial for him was erected on the road into the reservation. He was awarded the Bronze Star and the Good Conduct Medal. He started a blog, Through Amber Lenses. One of the entries reads as follows: "Two young boys crept closer, stopping about ten meters ahead of us. I motioned to them to come closer while Todd called to them in broken Arabic. Cautiously, the older of the two darted up to us. Todd pulled a pack of gum from his pants pocket and handed a piece to the boy, who looked confused but optimistic. Todd pulled out another piece for himself, and popped it in his mouth. The boy smiled and darted back to the safety of his house. When he stuck his head out a moment later, he was chewing happily and surrounded by a new group of local kids.

I motioned again to them, and a younger boy came running up over the broken bricks and dirt littering the street. I handed him a little pack of SweetTarts as my squad started moving back to the police station. He accepted happily and ran back to the house. I turned and followed the squad out of the neighborhood and back through the guarded station entrance, offering the lone IP a wave as he closed the gate behind me." Nora passed away on December 21, 2013; Jordan and Nora are together again. (Courtesy of Holly Shay.)

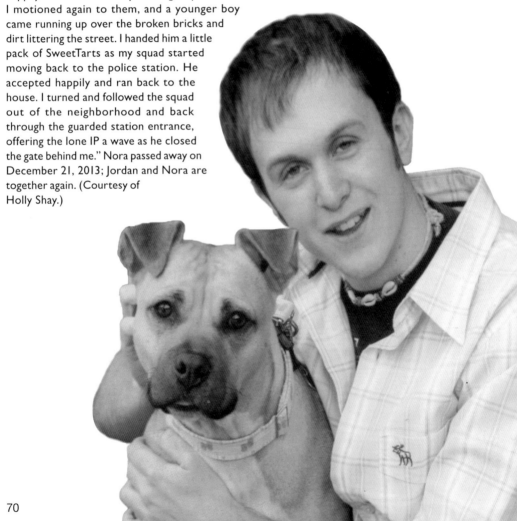

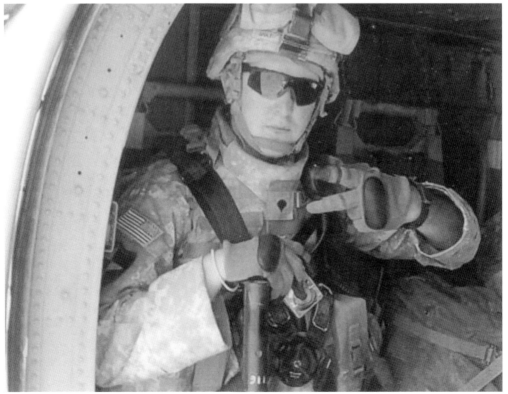

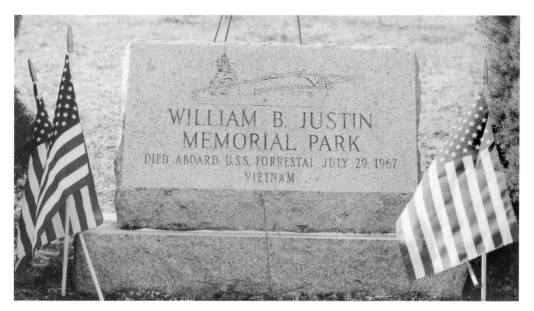

William Justin
Justin was aboard the USS *Forrestal* as it was conducting combat operations off North Vietnam in 1967. A rocket from an F-4 Phantom was accidentally launched across the deck, hitting the fuel tank of an armed Skyhawk. The impact caused a 1,000-pound bomb to fall into the fire. The incident resulted in 134 deaths and 64 injuries. Amesbury's Veteran Memorial Park is dedicated to Justin, who was on board the ship. (Photograph by Joey Walker.)

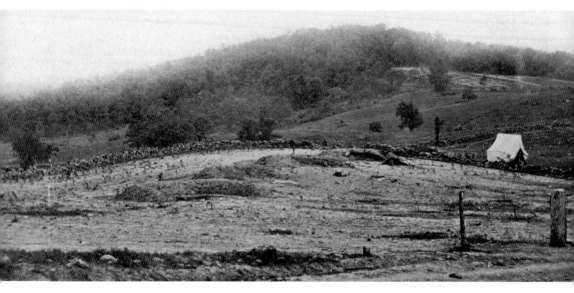

Myles Moylan
Moylan (1838–1909) was born in Amesbury and was educated in local schools. He worked as a shoemaker. He enlisted as a private in Company C and US Dragoons under Lieutenant McArthur in Boston. He fought against Indians and led fights at Brandy Station, Aldie, Middleton, Gettysburg (pictured), and Little Big Horn. He led his company against the Nez Perce and won a Medal of Honor for it. (Photograph by Library of Congress.)

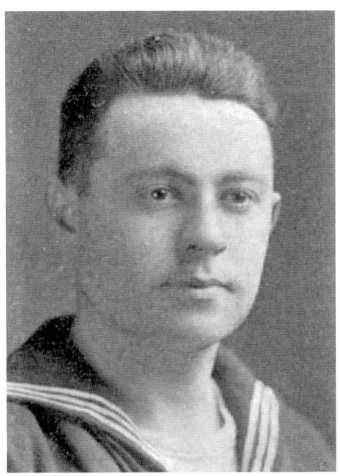

John Thornton
Thornton was born in Amesbury in 1891. His Army career began at Fort Devens, then continued to Camp Merritt. He was assigned to Company A, 302nd Machine Gun Battalion. Thornton was sent overseas to France, serving in command of a machine gun strongpoint. After only a few weeks, he was killed by a German shell. Thornton was the first Amesbury man to be killed in action in World War I. In 1919, Thornton Square was dedicated on Friend Street (below).

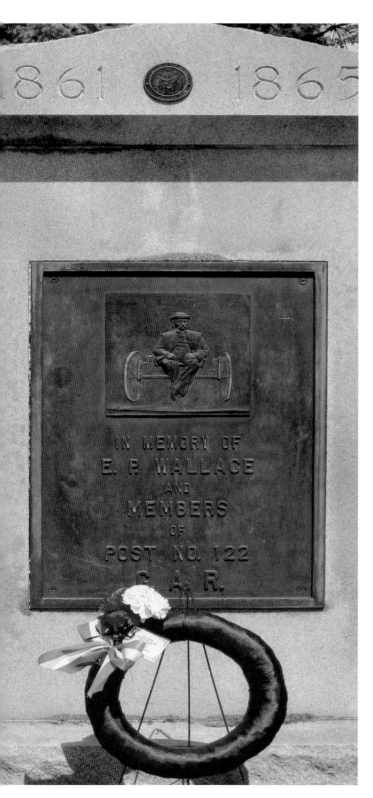

Edward P. Wallace
Wallace was born in Homer, New York, in 1833. He claimed Amesbury as his home for 65 years. At 18, he was apprenticed to a shoemaker to learn the trade of cordwainer and came to Amesbury in 1858. An unfortunate accident as a small boy rendered both of his legs unusable. In 1861, a town meeting was held to consider raising a local volunteer company to augment the ranks of the Union army. The hall was packed with patriotic citizens. Several people pledged money to equip uniforms and to help volunteers and their families. Wallace pledged the only money that he had to his name, $100. Amesbury's Grand Army post was named for E.P. Wallace. He was remembered for his gift at the outbreak of the Civil War. On December 8, 1926, the Women's Relief Corps dedicated a memorial in McNeil Park to Wallace and the members of the E.P. Wallace Post No. 122, Grand Army of the Republic. (Photograph by Joey Walker.)

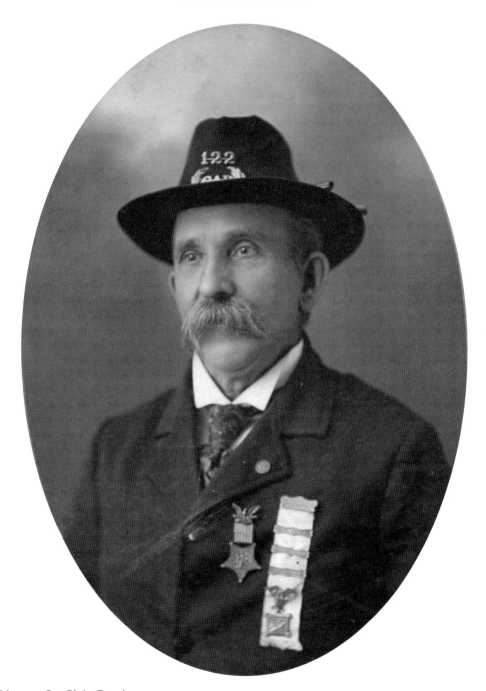

Alanson St. Clair Currier
Currier was the son of Sawyer Currier and a direct descendant of Richard Currier, one of the first settlers of Amesbury. He enlisted in the Civil War in 1862, serving for three years in Company I, 40th Massachusetts Regiment. He was in 20 battles, including at Cold Harbor and Richmond, Virginia. He was taken prisoner in 1864 and sent to Libby Prison in Salisbury, North Carolina. He carried a picture of his fiancé in a locket. He hid the locket under his tongue so it would not be detected. The locket is still in the family. (Courtesy of Sally Lavery.)

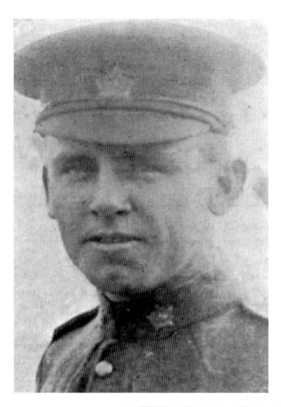

Earl L. Buchanan
Buchanan (1895–1916) was born in Lowell Town, Maine. He moved to Amesbury when he was young. He enlisted in the 55th Canadian Battalion at New Brunswick. He sailed for England, then was sent to France, where he was transferred to the 13th Battalion, Canadian Royal Highlanders, known as the famous Black Watch. During a mission, a German shell exploded and he was killed. His body was never recovered.

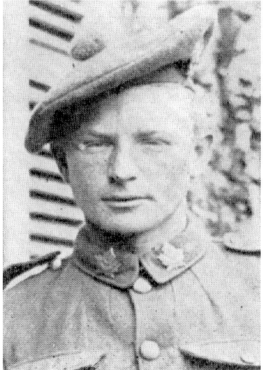

Edward Porter
Porter (1893–1917) moved to Amesbury as a young boy. He enlisted in the 72nd Seaforth Highlanders, Canadian Militia. Porter then went on to France, where he was killed by an enemy shell while leading his section in an attack at Passchendaele.

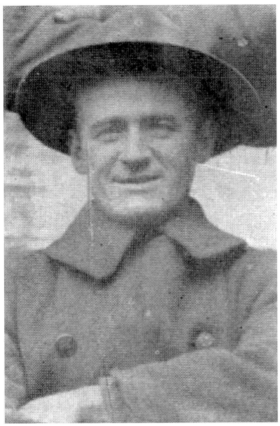

Luke F. Moran

Moran (1888–1918) was born in Amesbury. He enlisted in Company F, 8th Regiment, Massachusetts Volunteer Militia at Haverhill. This unit became Company F of the 104th Infantry. While stationed in France, he was cited for bravery by the French commander and was awarded for volunteering for the carrying and identification of the dead during the battles. (Amesbury's Part in the World War.)

Donney Brown Easson and Gerald Easson

Sgt. Donney Brown Easson (left) scouted Japanese soldiers. Donney was in the US Marines for three years as part of the War Canine Unit and served in the 6th Marines unit. The unit's men watched Donney flush out 37 different Japanese ambushes on Okinawa. Cpl. Gerald Easson was Donney's handler. They were both wounded at Peleliu. Donney was supposed to go home to New York, but his owner felt that he should stay with Gerald.

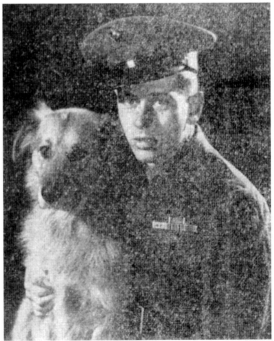

June Pritchard
Across the English Channel, a unit of the 109th Evacuation Hospital was set up under tents to tend to the wounded from the invasion on June 6, 1944. Pritchard was a nurse there, working alongside the doctors. The 109th was attached to the 3rd Army, Gen. George Patton's division. A month later, the unit was set up in Utah Beach to tend to the wounded. Pritchard was also a reference librarian at the Amesbury Library. (Market Street Baptist Church.)

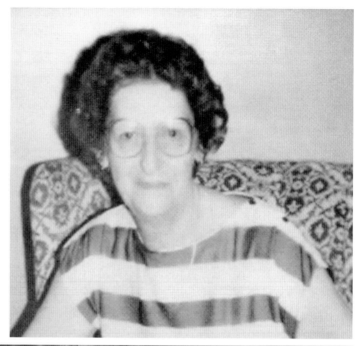

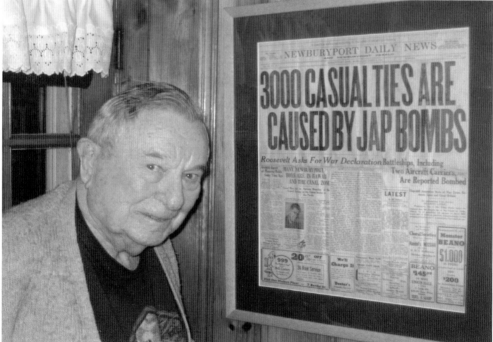

Robert Antell
Antell was born in Salisbury in 1920. He went to Amesbury High School and was an outstanding football player. He enlisted in the US Navy in 1939 and was witness to important events during World War II. While serving aboard the USS *Chester* in Pearl Harbor, he saw the destruction of a plane crashing into a hospital 200 yards away from him, plus many more atrocities. (Courtesy of Paul Jancewicz and Ski Iworsky.)

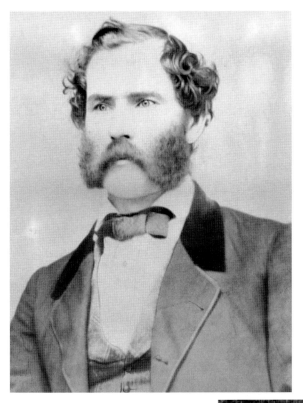

Albert S. Follansbee

Follansbee (1824–1891) was born in Salisbury. At the outbreak of the Civil War, he was captain of the Lowell Phalanx Company C, 6th Regiment. He took the lead as the regiment marched through Baltimore on April 19, 1861. There was terrible fighting with a mob of people; four soldiers lost their lives and several were wounded.

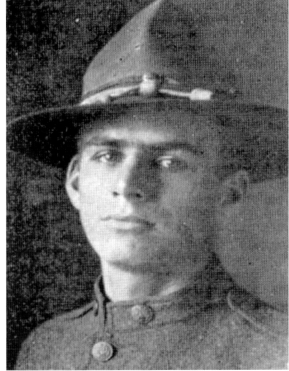

Leroy F. Goddard

Goddard (1892–1918) enlisted in 1916 and served on the Mexican border. In 1917, he was called for guard duty in Boston at the Charlestown Navy Yard. He was then mobilized to France, where he saw active service in the trenches. He was severely gassed and was in the hospital for months. He contracted pneumonia and died in 1918.

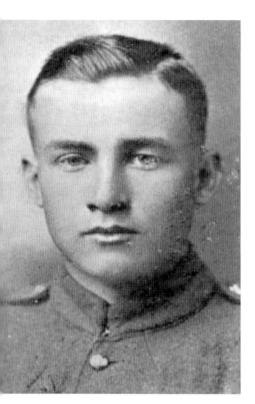

Harold J. McNanley

McNanley (1900–1917) enlisted in the Canadian army at 15 years old. After three months, he went to England and then was sent to France. For almost a year, McNanley served in the trenches of Northern France and Belgium. He was stricken with trench fever and ordered home. The boat he was on was shipwrecked near Halifax. He died of exposure at 17 years of age.

Disabled Veterans Memorial

The Disabled Veterans Memorial honors all of the disabled veterans from Amesbury and surrounding communities. The memorial is on the grounds of Union Cemetery. (Photograph by Joey Walker.)

CHAPTER FIVE

Public Service

I was asked to come to Amesbury and do some private nursing, so I came and liked it around here, so I stayed. I had the nursing home because I loved people and wanted to be good to those who were ill and make them comfortable. I know what it means to them, and by having a nursing home I could take care of more people than just being a nurse.

—Ruby Cunningham

People who are in public service do so because they love it. Teachers, priests, firemen, policemen, doctors, politicians, nurses, and historians are the people who have helped create Amesbury. Innovative teachers have brought foreign languages to the schools, taught students how to read and write, saw them off to war, and wrote letters to them to keep their spirits up. Teachers have helped mold students so that they can be successful in their endeavors. These are the people that aren't looking for a pat on the back; they are doing it because they care. Priests and pastors have created a community of parishioners from different religious backgrounds and nationalities. For example, Sacred Heart was instrumental in helping the French acclimate themselves to their new home. Firemen and policemen risk their lives every day to keep our neighborhoods safe. They stay on top of the latest technology and provide education to the community so people can be aware and stay informed. Politicians have helped the city evolve by bringing in new businesses and applying for grants to make Amesbury a better place to live. Public servants come from all walks of life, but they have one thing in common: they are there to make the community a better place to live.

George Washington
President Washington crossed the Merrimack River, from Newburyport to Amesbury's Point Shore, near where the frigate *Alliance* was built. This plaque reads, "Site of Ferry / 1669–1792 / Near this location / Washington crossed the river / on October 31, 1789. / Erected by / Josiah Bartlett Chapter / Daughters of the Revolution." (Photograph by Joey Walker.)

Moses Perry Sargent
Judge Sargent (1846–1928) was born in Amesbury. He was educated at local schools and at the Literary and Scientific Institute of New London, New Hampshire. He opened a law business without having earned a law degree. He was appointed a trial judge to hear small civil cases. In 1888, Sargent was appointed senior special justice, a position he held until his death.

Firemen Dedication

The Firemen's Memorial was dedicated on June 12, 1933, at Union Cemetery. In the photograph below, Chief James Feltham and assistants Eugene Titcomb and George MacDougall unveil the memorial. The Sibley Firemen's Relief Association was established after a fire at E. Ripley Sibley's house. In appreciation of the work of the firemen, he donated $100. All active members of the fire department are members of the Sibley Association. (Right, photograph by Joey Walker.)

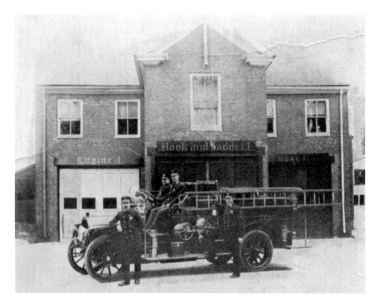

James Feltham

Feltham (1864–1943) was born in Warehouse Point, Connecticut. He was a member of the Amesbury Fire Department for more than 50 years, 35 of which he was chief. He transformed the department from the hand-drawn horse cart days to its present state of performance and technology. Feltham was a member of the Warren Lodge, AF and AM, and Trinity Chapter.

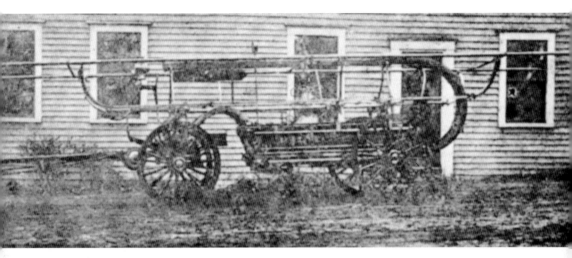

Protection 2, Amesbury Veteran Fireman's Association
The Amesbury Veteran Fireman's Association was organized on November 15, 1898. Officers of the association were Bernard J. Manning, president; John A. Reddy, vice president; Patrick Manning, recording secretary; and George W. Crowther, treasurer. Officers of Engine Protection 2 were John J. Riley, foreman; John A. Reddy, first assistant foreman; Frank W. Wilbur, second assistant foreman; and Thomas Meehan, steward. A horse-drawn fire truck is pictured.

Thomas Macy
Macy, originally residing at the Salisbury Plains, became the first town clerk for Amesbury, in 1645. He was one of the first settlers on the west side of the Powow River. Macy and Richard Currier were granted the right to start a sawmill. Macy sold his house to Anthony Colby (pictured) and relocated to Nantucket.

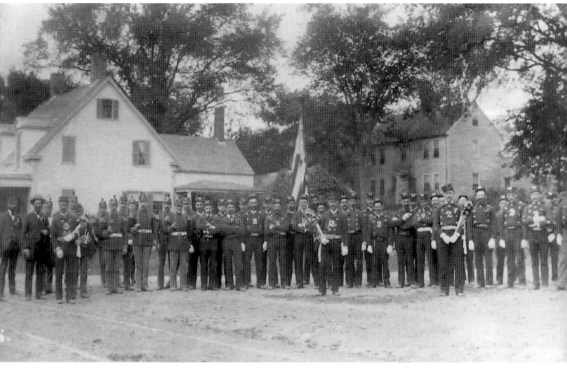

Point Shore Volunteer Firemen
Seen here in 1880, the Point Shore Volunteer Fire Company was located on Main Street in Amesbury. The company had an old fire engine. Unfortunately, the names of these volunteers are not known.

Colin J. Cameron
Cameron (1879–1958) was the owner of Whittier Press. He was a member of the state legislature for 14 years, serving six terms. An athlete in his youth, he was interested in sports all his life. He contributed to Amesbury High School Athletics and Little League, which he helped form. Cameron organized the Amesbury Mandolin Club in 1917, and he played with the Cadet Band. He is shown here with his daughter Catherine Cameron Capp. (Courtesy of Julie Capp Cairol.)

James W. Clark
Clark, born in Amesbury, attended local schools but left Amesbury High School to learn the carriage trade. He worked at his uncle John H. Clark's factory. In 1904, he and his brother Thomas took over the business and renamed it Clark Carriage Company. In 1916, the company closed, and he became a Buick sales agent in Amesbury. James built a sales garage on Sparhawk Street.

Hawley Patten
Patten, a descendant of John Hoyt, was involved with the city of Amesbury since his graduation from Amesbury High School in 1923. His deep commitment to Amesbury is reflected in the various organizations in which he was involved. He was president of the Amesbury Improvement Association, named Citizen of the Year by the Council of Churches, active in the Bartlett Museum and the Amesbury Educational Foundation, head of the street-lighting committee, and a town meeting member.

John J. Allen

Allen (1868–1960) was president of the Provident Institution for Savings and the longtime owner of a news agency and bookstore. He served on the town finance committee, was a town treasurer, was on the board of the Union Cemetery Commissioners, was a hospital trustee, and served on the water commission. He authored the book *Amesbury Carriage and Auto Industry*, a comprehensive account of all of the manufacturers in the town.

Willard Flanders

Flanders was a local historian, photographer, lecturer, artist, and expert on covered bridges. He was chief steward at the Rocking Hill Meeting House, chairman of the town history committee, a genealogical researcher, a member of the Bartlett Cemetery Committee, a curator at the Macy-Colby House, and was a trimmer at Biddle and Smart, a carriage and auto body manufacturer. He worked at W.E. Fuller Clothiers for 31 years.

James H. Walker
Walker was born in Amesbury in 1872. He attended Amesbury Schools and graduated from Bryant and Stratton's Commercial College. In addition to his work as a carriage manufacturer and state senator, Walker was chairman of the Republican Town Committee, a member of the Warren Lodge, and president of the Wonnesquam Boat Club.

Forrest Brown
Brown (1868–1943) was principal of Amesbury High School from 1895 to 1939. In 1909, he was honored with the title "One of the Best Principals in the State." He had graduated from the high school in 1887. During his tenure, enrollment increased from 300 to 900 pupils. He was secretary of the Rotary Club for 27 years, vice chairman of the local Red Cross, and served with the Lone Tree Council Boy Scout Troop.

Edward F. Messner
Dr. Messner graduated from Harvard School of Medicine and was on the faculty of Harvard University as an assistant clinical professor in psychiatry. He was a flight surgeon in the Air Force and an advisor to the Korean surgeon general. Messner was on the school committee, was a library trustee, and was an Amesbury Hospital staff consultant. Commuters on Route 95 would see him driving his car down the highway while wearing his crash helmet. He felt that one could not be too careful.

Harland J. Main
Main settled in Amesbury in 1946 after he married his wife, Marion. He was in the Army Air Corps during World War II. In 1953, he joined the Powow River National Bank. He worked for 40 years in banking, retiring as president of the Northeast National Bank in 1993. Main was active in the community; he was involved with the Lions Club and the Bartlett Museum. He enjoyed coaching his son in Little League. (Courtesy of the Main family.)

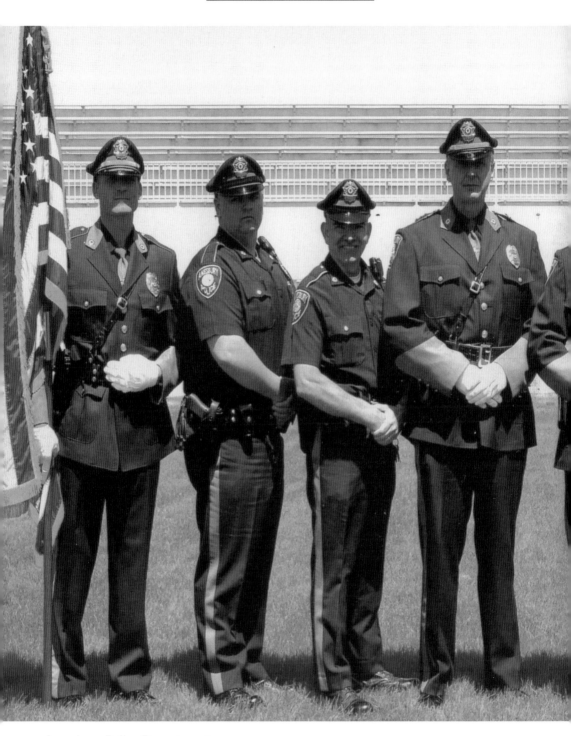

Amesbury Police Department
The Amesbury police has been keeping the town safe in these changing times. Here, some of the current police officers pose at the Memorial Day ceremony at Landry Stadium in 2013. They are, from

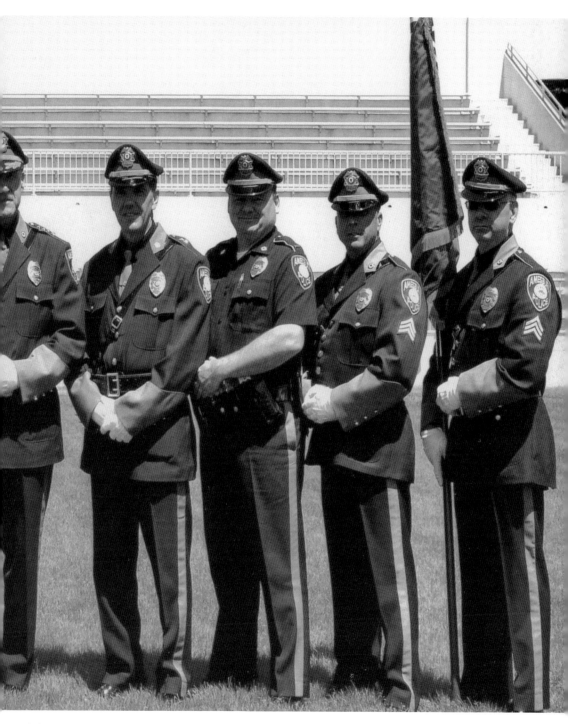

left to right, Sgt. Michael J. Purvis, Officer Jonathan G. Morrill, Officer Thomas G. Hanshaw, Lieutenant Executive Officer Kevin J. Ouellet, Chief Mark Gagnon, Lt. Det. Jeffrey P. Worthen, Acting Lieutenant Kevin Donovan, Sgt. Richard A. Poulin, and Sgt. William A. Scholtz. (Photograph by Joey Walker.)

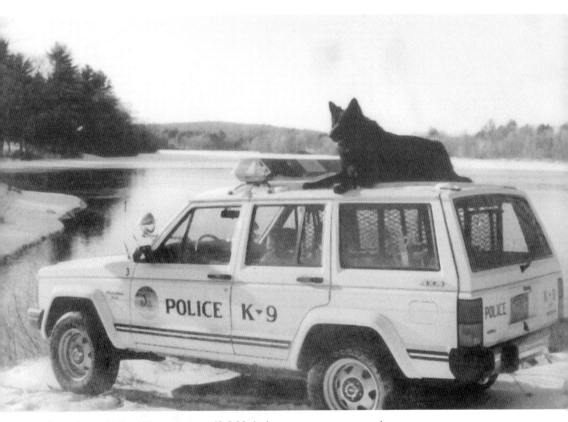

Amesbury Police Department K-9 Unit (ABOVE AND OPPOSITE PAGE)
The K-9 unit, established in 1978, is one of the oldest in the state. It was founded by Chief Cronin, who was partnered with K-9 Barron; Lieutenant Ouellet, partnered with K-9 Wess (pictured on the opposite page); and Sergeant Poulin, partnered with K-9 Cujo (pictured above), then K-9 Barry. Officer Nichols partnered with K-9 Hans. When Hans unexpectedly passed away, Nichols was assigned Kaybar. K-9 Kaybar received his National Certification in patrol through the US Police Canine Association and his National Certification in Narcotics Detection from the North American Police Work Dog Association. (Photographs by Chief Kevin Ouellet; courtesy of the Amesbury Police Department.)

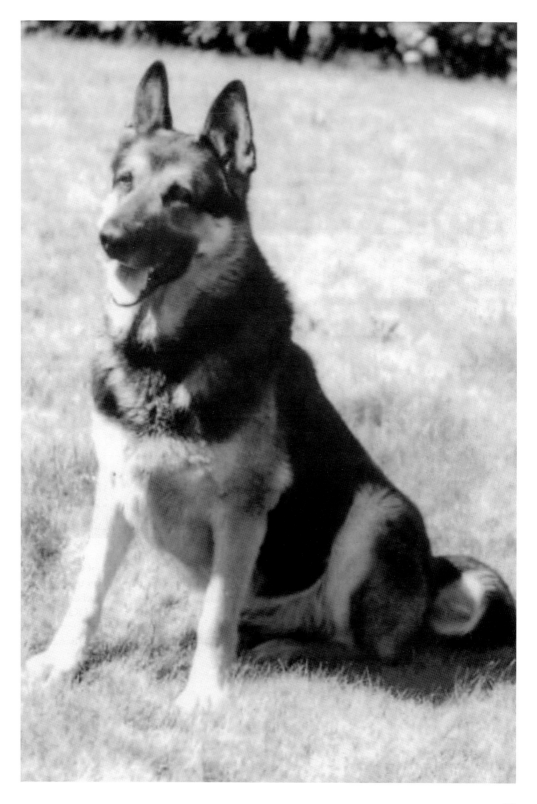

Thomas Hanshaw

Hanshaw was born in Amesbury and went to Amesbury schools. He joined the Amesbury Police Department in 1983. He became the crime prevention officer in 1996 and works closely within the community. He is involved with the Rotary Club bike safety, Fill a Cruiser for Our Neighbors' Table, instructs seniors on how to be safe, and works with Relay for Life. Hanshaw talks to elementary school children about the use of seat belts, being home alone, how to use 911, and staying away from strangers. He is one of the organizers of National Night Out. He writes a weekly column for the *Amesbury News* on safety tips. (Photograph by Joey Walker; courtesy of Tom Hanshaw.)

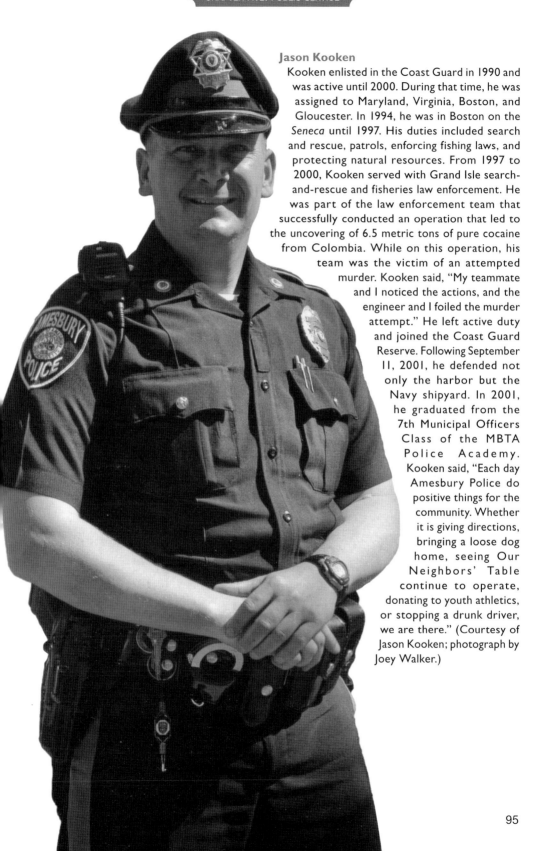

Jason Kooken

Kooken enlisted in the Coast Guard in 1990 and was active until 2000. During that time, he was assigned to Maryland, Virginia, Boston, and Gloucester. In 1994, he was in Boston on the *Seneca* until 1997. His duties included search and rescue, patrols, enforcing fishing laws, and protecting natural resources. From 1997 to 2000, Kooken served with Grand Isle search-and-rescue and fisheries law enforcement. He was part of the law enforcement team that successfully conducted an operation that led to the uncovering of 6.5 metric tons of pure cocaine from Colombia. While on this operation, his team was the victim of an attempted murder. Kooken said, "My teammate and I noticed the actions, and the engineer and I foiled the murder attempt." He left active duty and joined the Coast Guard Reserve. Following September 11, 2001, he defended not only the harbor but the Navy shipyard. In 2001, he graduated from the 7th Municipal Officers Class of the MBTA Police Academy. Kooken said, "Each day Amesbury Police do positive things for the community. Whether it is giving directions, bringing a loose dog home, seeing Our Neighbors' Table continue to operate, donating to youth athletics, or stopping a drunk driver, we are there." (Courtesy of Jason Kooken; photograph by Joey Walker.)

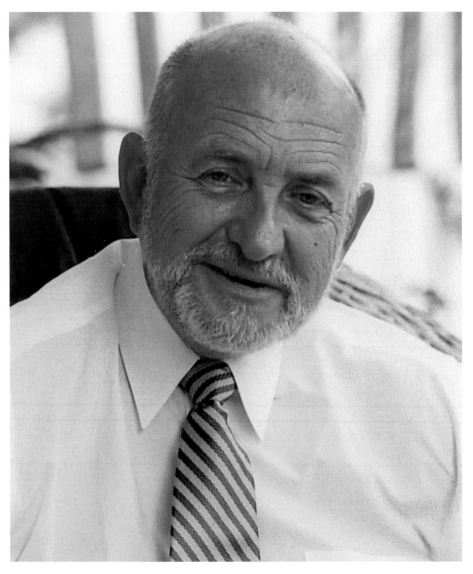

Nicholas Costello

Costello was the first mayor of Amesbury, elected in 1996. At that time, the town form of government was changed to a city form of government. Costello served as mayor for five years. He has been in the public eye for many years. He was a selectman from 1972 to 1976, was on the Amesbury School Committee from 1978 to 1983, a state representative from 1983 to 1990, and a senator for three terms. Costello started Link House 40 years ago, which is a program for men with drug and alcohol addiction. He is the chief executive officer and executive director of Link House, managing four addiction recovery programs and facilities. Costello continues to be a frequent participant in the heritage and cultural activities in and around Amesbury, Salisbury, and Newburyport. He has been the recipient of many awards, including "Legislator of the Year" by the National Cancer Society for introducing legislation requiring insurance companies to offer free mammograms and pap smears to all women in the commonwealth. His wife, Cynthia, benefited from these tests by detecting her cancer early and being able to get successful treatment. Nicholas and Cynthia have been married for more than 50 years, and they have five sons. (Courtesy of Nicholas and Cynthia Costello.)

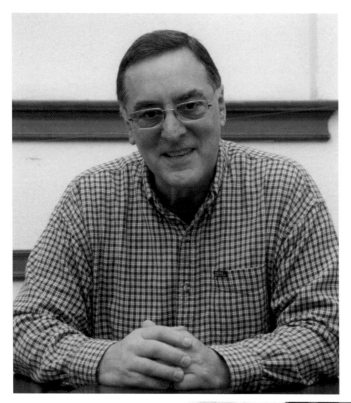

David Hildt
Hildt was mayor of Amesbury from 2002 to 2006. He provided continuity and brought people together. His accomplishments were the Upper Millyard and smart growth, which continues to this day. Hildt said that being mayor was a wonderful experience, educationally rewarding and engaging. He enjoyed working with the people of Amesbury, particularly those who did the day-to-day work to keep the city running. (Photograph by Joey Walker; courtesy of David Hildt.)

Thatcher W. Kezer III
Mayor Kezer has been in office since 2006. His focus is on excellence in delivering core services. A lieutenant colonel in the Air National Guard, he has served in the Guard for 33 years. His current position is director of Cyberspace Operations. Kezer is an avid hockey player. (Photograph by Joey Walker; courtesy of Mayor Thatcher Kezer.)

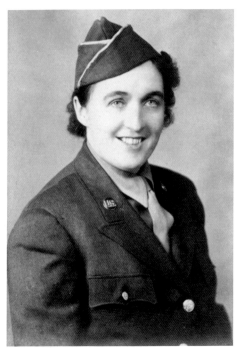

Sara Locke Redford
Redford was educated in the Amesbury schools and went to American University in Washington, DC. She taught social studies at Amesbury High School and was active with the school band for more than 20 years. She played with the Boston Women's Symphony. Redford brought Spanish language classes to the high school. During World War II, she joined the Armed Services. Redford was the author of the *History of Amesbury, Massachusetts*, which came out in conjunction with the 300th anniversary of Amesbury.

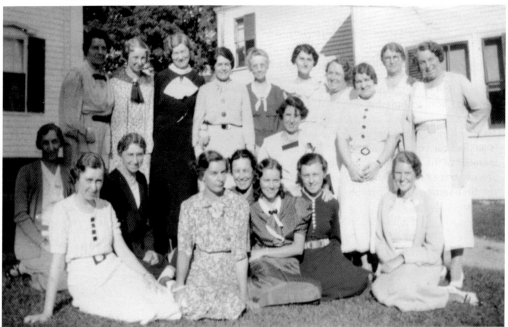

Kathleen H. O'Brien
O'Brien (1886–1970) was a schoolteacher at Davis School, Ordway School, and Amesbury Junior High. She taught civics and geography. As a civics teacher, she instituted annual pupil tours of the town departments and industries. The students gained knowledge of local government and manufacturing. She was a member of the Town History Committee and researched many facts for the 300th anniversary of Amesbury. O'Brien is seen here, standing at the far left.

Patricia Hoyt

Hoyt was born in Amesbury. She was head of the English department and the drama club, where she mentored Jeffrey Donovan and Gregory Hoyt. Hoyt is on the board of the Jeanne Geiger Center and is a member of the Amesbury Educational Foundation. She can trace her family back to John Bailey, one of the first settlers. (Photograph by Margie Walker; courtesy of Patricia Hoyt.)

Peter Hoyt

Hoyt graduated from Amesbury High School, the University of New Hampshire, and Salem State College. He retired from the Cashman Elementary School as principal. Hoyt is involved with the Carriage Museum, Bartlett Museum, and the Historic Commission. He is on the board of the Jeanne Geiger Center and is a school committee member. Hoyt sings at St. John's Episcopal Church in Beverly Farms. (Photograph by Margie Walker; courtesy of Peter Hoyt.)

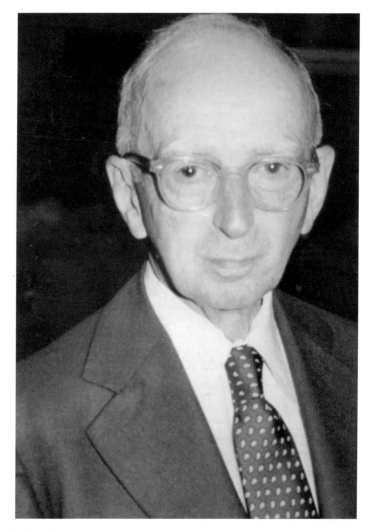

Roland H. Woodwell
Woodwell (1900–1995) was born in Newburyport, Massachusetts. He graduated from Newburyport High School, then from Harvard College in 1927 with a master's degree in education. He moved to Amesbury and taught English at Amesbury High School for 40 years, serving as a highly respected English department head until he retired. Woodwell spent 60 years researching the life of John Greenleaf Whittier, interviewing people who knew Whittier, then publishing his book *John Greenleaf Whittier: A Biography*. He authored another book, *Amesbury Public Library: 1856–1956*. He served the community as a trustee of the Amesbury Public Library and its charitable trust, was involved with the Whittier Home Association, and was a member of the Main Street Congregational Church, the Historical Society of Old Newbury, and the First Parish Church of Newbury. A beloved teacher and coach, Woodwell set up a gym in his barn so that Amesbury High School athletes could work out. He taught them boxing and tennis. At age 75, with encouragement from a former student, he began jogging. He had always walked, having never owned a car or obtained a driver's license. Students and colleagues drove him places. Throughout World War II, he corresponded with many Amesbury High School students who served in the war. Woodwell saved all of the letters, which are now preserved as a local historical document at Amesbury High School. The new library media center at Amesbury High is named after Woodwell. (Courtesy of Patricia and Peter Hoyt.)

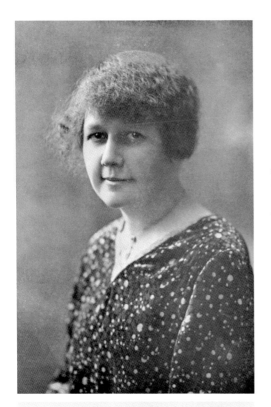

Mildred Phillips Neal
Neal was born in Amesbury and taught French at the Amesbury High School. She shared her knowledge with the Sisters of the Sacred Heart Parish, going to their convent to converse with them. Students at home and away are far richer by having had Neal as a teacher. She provided cultural insights while teaching them the French language. She was a descendant of Robert Jones and William Osgood, first settlers of Amesbury.

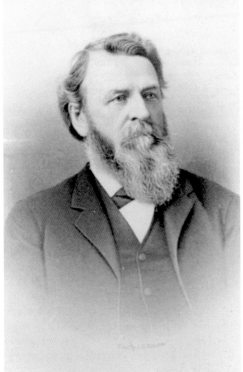

George W. Morrill
Morrill (1818–1886) was born in Amesbury. He was in the Massachusetts Legislator in 1876 and was one of the presidential electors that same year. In 1884, he was elected senator for the 4th Essex District. He was a well-respected man. Many citizens felt that the world was a better place because of Morrill.

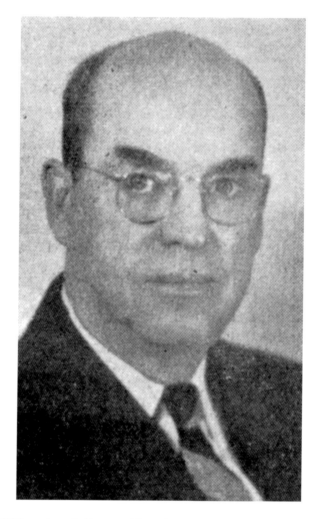

Otis Mudge

Dr. Mudge (1879–1962) was born in Danvers, Massachusetts. He graduated from Dartmouth College in 1903. In 1906, he graduated from Dartmouth Medical School, and the following two years he attended Harvard Medical School. He began his practice in 1909 in the Excelsior Block on Market Street in Amesbury. He was a member of the Dartmouth Alumni Association and the Dartmouth chapter of Beta Theta Pi. Mudge, one of the founders of Amesbury Hospital in 1927, was also a member of its staff. A member of the Warren Lodge and of the Main Street Congregational Church, he was also the Amesbury High School football squad physician. For 35 years, he was the physician at Camp Powow of Bay Shore Council Boy Scouts. He was a member of the Rotary, a civic leader, and aided fundraising of the Red Cross and YMCA. During the influenza epidemic of 1918, he worked around the clock. He gave financial help to families struggling to put children through college.

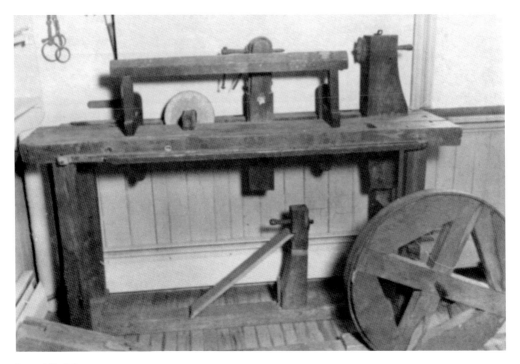

Israel Balch

Dr. Balch (1788–1855) was a graduate of Dartmouth College. He invented surgical instruments and appliances, receiving four patents. He gained a good reputation as a surgeon from his successful amputations of limbs, and he constructed a lathe for artificial limbs (pictured). In his spare time, he made clocks. Balch also lectured on chemistry and electricity. In 1822 and 1823, he was an assessor and a member of the committee of Amesbury and Salisbury Universalist Church.

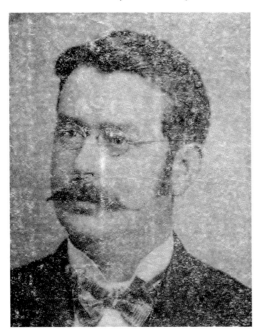

Daniel D. Murphy

Dr. Murphy was born in East Haverhill in 1864. He practiced medicine for 50 years. He was one of the pioneers in the movement for the Amesbury Hospital. He believed the hospital was one of the greatest assets to the town. Murphy was known for being on call 24 hours a day. He was the first medical examiner for Amesbury, a position he held for 35 years, and he helped young people start their own practices.

Louise Stilphen

Since the age of eight, Stilphen wanted to open a school. She credits her parents and the lovely private school that she was able to be a part of. Stilphen envisioned her dream and wrote down her beliefs and philosophy of what the school would be like. The 20-page work was then condensed to a postcard. She bought a bus and added the phrase "Honoring children celebrating ideas." Adhering to the idea that a school does not have to be big, Stilphen started the Sparhawk School in her home, eventually moving it to the Farm on Elm Street. The school opened in 1994 with 11 students at the beginning of the year and ended the year with 18. The second year, 35 kids were enrolled, and at the end of the third year, there were 76 students. The school has grown over the years, but the students are instructed in small classrooms. The school has added an international program, which allows children from other countries to come and stay. In addition, the school has acquired a residence so that students from other states can come and have the Sparhawk experience. The school's students have a 100-percent acceptance rate at colleges. Stilphen is passionate about the school, the students, and the faculty. She loves what she does, and it shows. One student expressed her feelings this way: "Sparhawk gives their students the opportunity to expand their minds, develop a passion for learning, and have love for one another." (Photograph by Joey Walker; courtesy of Louise Stilphen.)

Jean Baptiste Labossiere
Reverend Labossiere was born in Quebec, Canada. He studied at Ste. Marie College of Montreal, Brighton Seminary in Boston, and the University of Boston. He was the first pastor of the new parish at Sacred Heart Church, serving from 1903 to 1913. Labossiere purchased a home next to the church. When he left, the house became part of the parish.

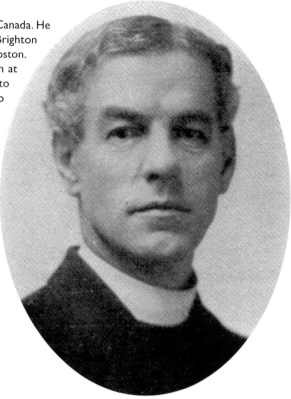

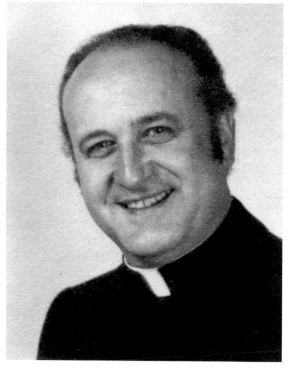

Rene Dufour
Reverend Dufour was born in Lawrence, Massachusetts. He was ordained by Cardinal Richard Cushing. While in Amesbury, he started the Boys Choir and the Confraternity of Christian Doctrine program. Parishioners talk about his July 4, 1976, display of American flags in the church. He was on the committee for the 75th anniversary of Sacred Heart Parish.

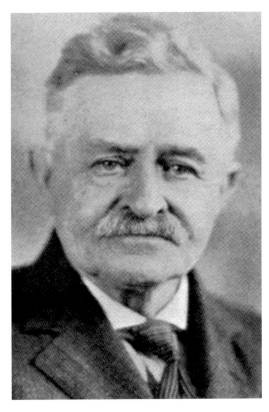

Andre Brochu
Brochu was known to parishioners of Sacred Heart Parish as "Papa." He became the first selectman of French-Canadian origin in Amesbury. He was one of the founders of the Old St. Jean Baptiste Societe and the Lafayette Club. Brochu, along with Dr. Arthur Savignac and Valerie Cote, was on the committee to create the Sacred Heart Parish.

Valerie Cote
Cote, a baker by trade, arrived in Amesbury in 1866. He was on the committee to bring a French-Canadian parish to Amesbury. He was successful in his pursuit of creating the Sacred Heart Parish.

Arthur Savignac

Dr. Savignac was born in Quebec, Canada, in 1861. He was a devoted physician to the people of Amesbury. He was on the committee that went to see Fr. John J. Nilan to present a Letter of Presentation to Msgr. John Williams, archbishop of Boston, requesting a new parish. It was announced a week later that the request was accepted. Within a month, land had been purchased for $3,000, and Sacred Heart Parish was born.

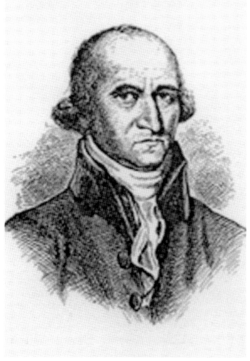

Paine Wingate

The Honorable Paine Wingate (1739–1838) was born in Amesbury. He graduated from Harvard in 1759, where he studied theology. He was ordained a minister of the Congregational Church in Hampton Fall, New Hampshire. He was a delegate to the US Congress of Confederation (1787–1789), a US senator (1789–1793), and a US representative (1793–1795). From 1798 to 1809, Wingate was a judge on the New Hampshire Superior Court. (Courtesy of the Library of Congress.)

Rev. J.C. Fletcher
This home was purchased by Reverend Fletcher in 1866. It was known as Hawkswood. Fletcher, a naturalist and author, was a missionary to Brazil and the secretary to the US Legation at Rio de Janeiro. He was also the US consul at Oporto, Portugal.

Ruby Cunningham
Cunningham was born in England in 1892. She graduated from the Barre City Hospital in Vermont and worked for many years at Massachusetts General and Anna Jaques Hospitals. She was a deaconess at the Market Street Baptist Church for 25 years. Cunningham was a member of the Massachusetts Board of Baptists Convention, Guild for the Blind, and Essex County State Grange. She received a Community Service Award from the House of Representatives. (Photograph by Market Street Baptist Church.)

CHAPTER SIX

Community

We are dedicated to funding and inspiring acts of kindness in local communities that can change the world one act at a time. Kindness is contagious.

—Danielle Levy and Dorothy McGrath, Littlest Change, Amesbury

People are the cornerstone of every community. When residents come together, fabulous things can happen. Women started organizations to help the less fortunate. They became presidents of various organizations in town, started guilds at their churches, raised funds by making items to sell, and started a hat museum. Men came together to chop wood in the middle of Market Square to give to families that could not afford it and established clubs so that people of different nationalities had a place to go when they arrived in town. Amesbury is truly a community of people that come together when one of its own needs assistance. Citizens jump into action by creating fundraisers or preparing food to help not only the affected person, but the whole family. In addition, the community does not just do things for local people, but for those in other communities throughout the United States. The people of Amesbury let others know that they care and are with them in spirit. Amesbury is a global community.

Lion on Lions Mouth Road
The Lion was brought to Amesbury by Nathaniel Currier of the famed partnership of Currier and Ives, and it was given to the Woodsom Farm. People come from far and wide to see the lion. Lions Mouth Road was known as the Lion's Mouth District in 1790. (Photograph by Joey Walker.)

Sallie Sargent
Sargent (1865–1957) was the oldest member of the Market Street Baptist Church, having been a member for 80 years. She was a charter member of the Whittier Home and was its president for 21 years. She was in her twenties when John Greenleaf Whittier died, and she appreciated his citizenship and qualities as a man and a lover of freedom. She was involved in the Social Service Club of the Market Street Baptist Church. Her home is pictured. (Photograph by Joey Walker.)

St. Jean the Baptiste Society The Franco Americans of 1887 understood the benefit to individuals of establishing a group based on their common heritage. Basil Macra was voted the first president in 1887. The society held bazaars to raise funds and was able to buy an emblem banner of the society, incorporating a French flag and an American flag. Members of this society were responsible for naming Sacred Heart Church. (Photograph by Joey Walker.)

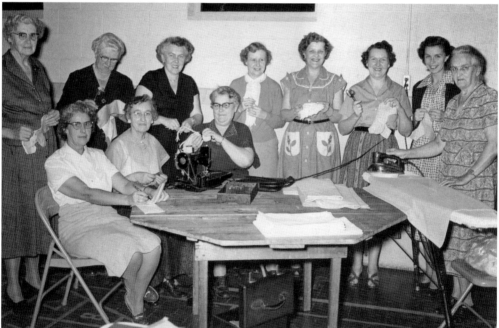

Woman's Guild of the Market Street Baptist Church
The work committee of the Woman's Guild is seen here preparing for the annual fair and Christmas sale. Shown here are, from left to right, (seated) Alice Wells, Olive Church, and Edith Worthen; (standing) Mary Souther, Ada Carter, Barbara Marble, Ruth Ross, Beatrice Burke, Gertrude Terry, president and general chairwoman Ann Ludeking, and Grace Peaslee. The guild is responsible for programs, church fairs, and fundraisers. (Courtesy of the Market Street Baptist Church.)

 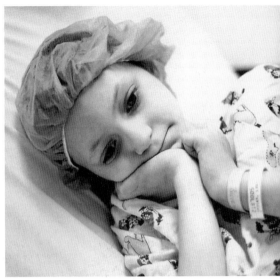

Lucy Grogan

Lucy (1994–2006) was eight years old when she was diagnosed with acute myeloid leukemia. She was a very spiritual person. When very little, she talked about Jesus and concepts that were very deep for a girl her age. Her mother, Beecher, felt that Lucy chose her to be her mother and that it was predetermined that Lucy would have cancer and, through her, Beecher would learn a lot. "I was born to do this and Lucy was born to teach me," Beecher said. "Lucy was a profoundly wise kid and taught people to see the silver lining in everything. She always looked on the bright side of having cancer. She would say 'if I did not have cancer, I would not have met my new friend.'"

Lucy was an activist at eight years old, having strong opinions about fairness and justice. On her seventh birthday, she made a beautiful handprint and wrote on the top "seven years gone." She made handprints and wrote "peace" and other words on them. Lucy was a free spirit, and she had an old soul. Lucy saw 15 friends die the first year that she had cancer. When Lucy relapsed, she discovered the benefit of integrative therapies such as massage, acupuncture, art therapy, and therapeutic horseback riding. Lucy told her mother that she wanted to start a program that would provide free integrative therapies to children undergoing treatment. Lucy's Love Bus was born. Since 2006, Lucy's Love Bus has been delivering love and comfort to children with cancer by offering integrative therapies that can help with the side effects of cancer treatment. Here are Lucy's words: "When you look at the sick children follow them to the place they can speak to you in. Notice their bodies are two things, love and illness, and help them remember the love, not the illness. The healing is in the knowing who you were, not what you might be." (Courtesy of Beecher Grogan.)

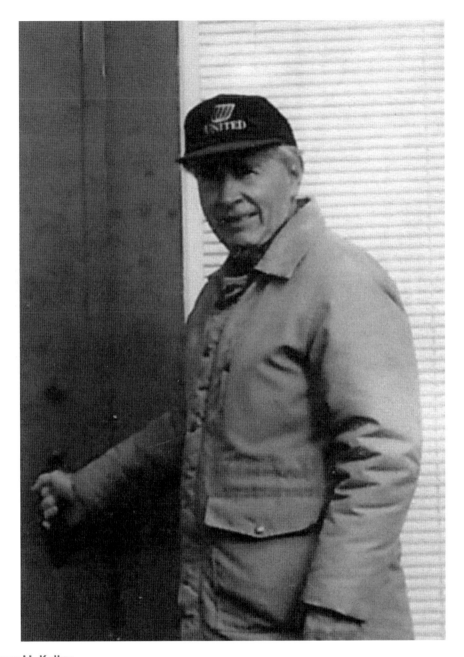

James H. Kelley
Kelley graduated from Somerville High School and earned a degree in physics from Tufts University. He served in the Navy during World War II. He was a member of the Electronics Technicians Guild and published the *ETG News* for many years. He was a technical writer at Raytheon in Andover and Burlington. Jim and his wife, Alison, moved to Amesbury in 1991. Although he did not live here long, he had an impact on Amesbury. He was very interested in local history and became involved in the Amesbury Carriage Museum. He was a member of the Amesbury Improvement Association and created brochures and marketing materials for the organizations that he was involved with. He loved photography and created slide shows about local history, presenting them to residents at nursing homes. (Courtesy of Karen Martel.)

Alison Kelley

Kelley created the Amesbury Hat Museum in 2004. She wanted to pay tribute to the American culture and the local workers that took part in the creation of the hats. The Merrimac Hat Factory was the largest manufacturer of trimmed hats and hat bodies in the country. She started to collect the hats, finding them at auctions. In addition to starting the Hat Museum, she also established the Friend's Book Shop at the Amesbury Public Library. She set up the shop in the lower level of the library. The funds raised go to library programs. She was a member of the Friends of the Amesbury Public Library and also volunteered with the local history collection. (Photographs by Joey Walker and Karen Martel; courtesy of Alison Kelley.)

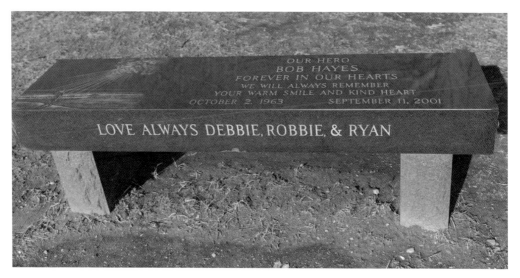

Robert Hayes

Robert Hayes (1963–2001) is a true American hero. He was on Flight 11, which crashed into the North Tower of the World Trade Center in New York City on September 11, 2001. He was devoted to his wife and two sons. (Photograph by Joey Walker; courtesy of the Amesbury Improvement Association.)

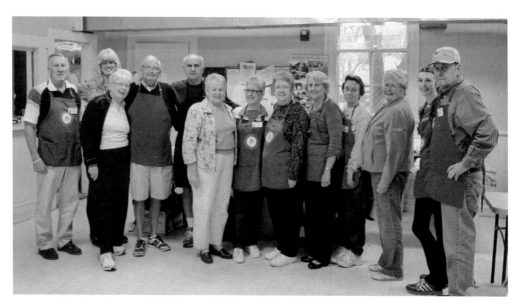

Our Neighbors' Table

Our Neighbors' Table was established in 1991 through the Amesbury Council of Churches. It offers a Wednesday meal to the community and a food pantry on Fridays and Saturdays. The pantry and dinner are conducted by very hard-working volunteers. Shown here are, from left to right, Jim Smith, Lori Townsend (pantry director), Cathy Gaudet, Bill Chisholm, Anthony Grillo, Carol "Sue" Ranshaw, Pat Smith, Betty Elliott, Sandy Smith, Dottie Johnson, Rita Plouff, Katie Duggan, and Ben Plouff. (Photograph by Joey Walker; courtesy of Our Neighbors' Table.)

Harriett Woodsom Gould

Gould was born in Amesbury and grew up on Woodsom Farm on Lions Mouth Road. There were nine children in her family, of which she was the oldest. She could often be seen out in the field driving the horses or farm trucks. During World War II, she was a nurse's aide at Amesbury Hospital. She married Robert in 1946, and they had three children. She worked to get the Macy Colby House in the National Register of Historic Places. She is involved with the Amesbury Educational Foundation, Bartlett Museum, Whittier Home Association, Amesbury Improvement Association, and the Amesbury Treasures. Gould is a person to look up to, a true leader who has made Amesbury a better place to live.

Dorothy McGrath and Danielle Levy
McGrath (left) and Levy created The Littlest Change, an organization that encourages people in the community to perform random acts of kindness. Some of the things they suggest are leaving popcorn at a Redbox kiosk; taping money to a magazine in a grocery store, and letting someone go ahead in line at a coffee shop or store. They have a Kids Care Program and a Business Partnership Program. According to Levy and McGrath, kindness is contagious. (Courtesy of Danielle Levy and Dorothy McGrath; photograph by Joey Walker.)

Edwin L. Noble
Edwin Noble was a pastor at the First Universalist Church from 1931 to 1936. He was not in Amesbury long, but he had a major impact on the community. He aided in the establishment of Goodwill Industries Store and served as chairman of the Red Cross roll call campaign. He helped hundreds of families that needed food, clothing, or heat for their home.

Rosemary Werner

Werner believes that when someone is a part of the community, he or she should be involved in the community. She has helped so many people in Amesbury over the years, including working with the homeless, providing sleeping bags. She was the executive director of Our Neighbors' Table, providing weekly meals. Werner brought the program "Be a Buddy not a Bully" to local schools. She is working to get the monuments in town cleaned and taken care of. She had schoolchildren make Valentine's Day cards, which were then sent to injured servicemen and women at Walter Reed Hospital. She organized events for the first anniversary of September 11 and then again on the 10th anniversary. She is the executive director of Best Foot Forward, an organization that helps people find employment, helps with their resumes and interview techniques, and offers professional outfits for their interviews. Werner started a program with Coastal Connections, bringing monthly birthday cakes to people involved in the program. She decorates the gazebo in the center of town for the Christmas holiday. She placed a book in city hall for residents to sign, which was then sent to Aurora, Colorado, in the wake of the movie theater shooting. This year, Werner involved Amesbury Middle School students in decorating hearts for each of the kids and adults that were killed in the school shooting in Newtown, Connecticut. She had a ceremony with local police, firefighters, and politicians so that the kids could hang the hearts on the tree. When a tragedy happens, people think to themselves, "What can I do?" Werner just does it, and she gets the community behind her. Everyone in the city of Amesbury knows that "you can't say no to Rosie." (Photograph by Joey Walker; courtesy of Rosie Werner.)

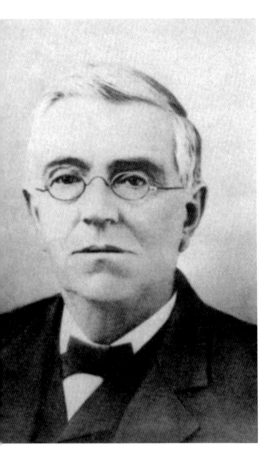

James H. Davis
Davis was the first librarian at the Amesbury Public Library. He was also secretary of the trustees. He owned an academy on Friend Street, where he was the principal. Davis received a yearly salary of $50. The library was open Saturday afternoon and evening. In 1867, it was opened on Wednesday as well, and his salary was raised to $75 per year.

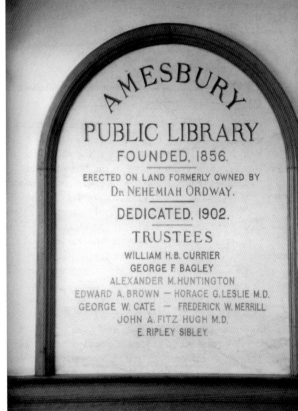

Nehemiah Ordway
Dr. Ordway (1711–1779) was born in South Hampton, New Hampshire. He married Patricia Bradshaw. Ordway graduated from Harvard Medical School. He dug a well on the corner of School and Main Streets. Old newspapers state that the water was the purest and coldest within miles. Dr. Ordway was popular with all classes of people, and he treated everyone the same. He donated land to the Amesbury Public Library. (Photograph by Joey Walker.)

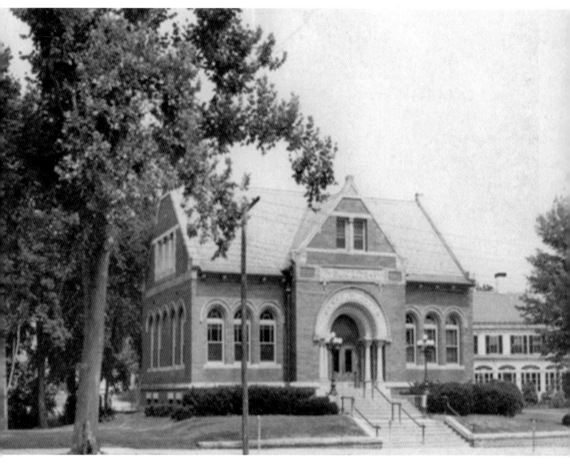

Amesbury Public Library

The Amesbury Public Library opened its doors on April 23, 1902. The three staff members, Alice Follansbee, Alice Brown and Ruth Osborne, stood to greet patrons as the doors opened. The next quarter of a century showed a steady growth. In 1908, a committee worked with the Amesbury High School principal and found that the library had enough history books for the students. Book lists were given to the librarian, and she carefully decided which books should be added or removed. Spring ahead 100 years, and the library has added a lot of new technology. Today, e-books can be downloaded, and patrons can check their e-mail, apply for a job, or write a resume. Patrons can check-out movies, audiobooks, and Playaways. Books can be renewed and accounts checked online. The library is the center of the community. People come in to catch up with old friends, meet for interviews, or tutor a student. There are a wide variety of programs for children, teens, and adults. The library has come a long way since 1902. (Courtesy of Amesbury Public Library.)

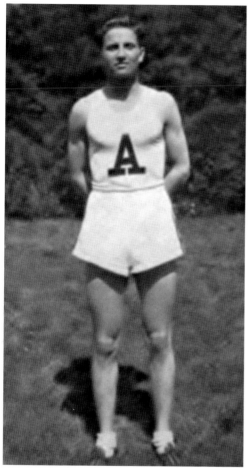

Pasquale Polletta

Pat Polletta was born in Amesbury. He ran three marathons in the 1930s and 1940s and became a US Merchant Marine. While in Africa, he was seriously injured after a 60-foot fall into the hold of his ship. The fall severed a spinal nerve, and as a result, he was paralyzed from the waist down. Polletta was determined he would live a useful life. He had a specially equipped car made so that he could continue to get around. He was on the faculty of the New England Military School in Byfield, Massachusetts, where he encouraged young people. As a Boy Scout leader, he encouraged boys to be all they could be. Polletta became an Eagle Scout when he was a boy. He has worked hard on behalf of paraplegics, seeking to give them encouragement. He participated in wheelchairs games and was the track coach at Amesbury High School. There is a yearly road race in Polletta's name to benefit the Amesbury High School running programs and Adaptive Sports Partners of the North Country.

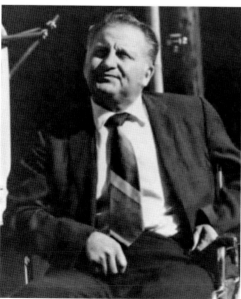

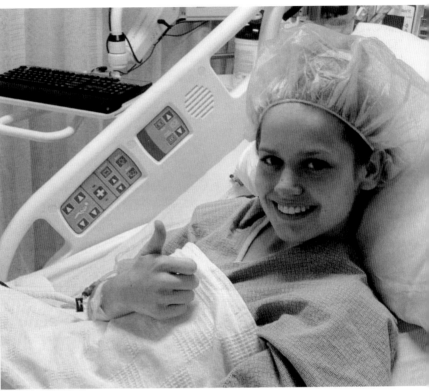

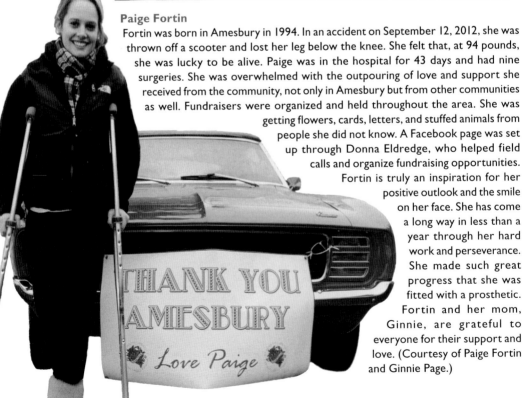

Paige Fortin
Fortin was born in Amesbury in 1994. In an accident on September 12, 2012, she was thrown off a scooter and lost her leg below the knee. She felt that, at 94 pounds, she was lucky to be alive. Paige was in the hospital for 43 days and had nine surgeries. She was overwhelmed with the outpouring of love and support she received from the community, not only in Amesbury but from other communities as well. Fundraisers were organized and held throughout the area. She was getting flowers, cards, letters, and stuffed animals from people she did not know. A Facebook page was set up through Donna Eldredge, who helped field calls and organize fundraising opportunities. Fortin is truly an inspiration for her positive outlook and the smile on her face. She has come a long way in less than a year through her hard work and perseverance. She made such great progress that she was fitted with a prosthetic. Fortin and her mom, Ginnie, are grateful to everyone for their support and love. (Courtesy of Paige Fortin and Ginnie Page.)

Carrie Cammett Ellis

Ellis was a friend of John Greenleaf Whittier when she was a child. Whittier called his young friend "Queen Maude." They had tea parties, and she played the piano for him. Ellis was involved in the Ladies' Charitable Society, Missionary Guild of Main Street Congregational Church, Whittier Home Association, and Friendship Chapter, Order of Eastern Star. She felt that she got her sense of helping people from Whittier.

The Female Charitable Society of Salisbury and Amesbury was established in 1828, and the town appreciated all the work the women accomplished. In 1837, a petition was sent to the legislature for incorporation of a society. The organization became the Ladies' Charitable Society of Amesbury. All ladies had to pay 50¢ into the treasury to become a member. They met once per year. The society assisted families in emergencies; members brought baskets of food, fuel, clothing, shoes, and furniture.

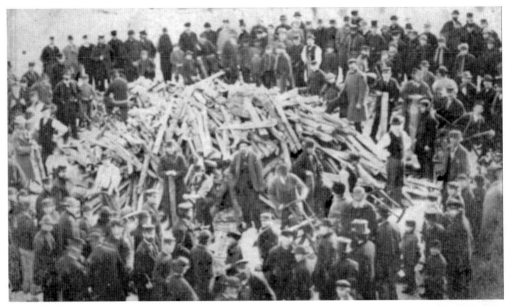

Hiawatha Club
Members of the Hiawatha Club of Amesbury and Salisbury are seen here in Market Square on January 18, 1868. They sawed wood for people in need. The members were trying to get other clubs to help them saw. They cut 13 cords of wood and delivered them to 46 families in less than four hours.

Polish Club
The club, whose full name is the Thadeus J. Koscioszko Society, Group 3058, Polish National Alliance, was chartered on July 5, 1918. Its purpose was to help Polish immigrants bridge the gap between the social and cultural customs of their homeland and their new home in America. There were about 65 Polish families, making up more than 300 people. High school principal Forrest Brown provided classes in civics and languages to help the new immigrants. (Photograph by Joey Walker.)

Candlelight Vigil for the Boston Marathon Bombing
On April 15, 2013, a bombing occurred at the Boston Marathon. Three spectators lost their lives, and hundreds more were injured. Amesbury came together to start the healing process in the wake of this terrible tragedy. Local dignitaries spoke of the healing process and how, as a community, citizens could get through the difficult time. Many volunteers came out to make this gathering happen. This is the true meaning of community. This is what Amesbury is all about. Residents come together to help each other, reaching out to each other and beyond, letting people in other communities know they care. (Photographs by Joey Walker.)

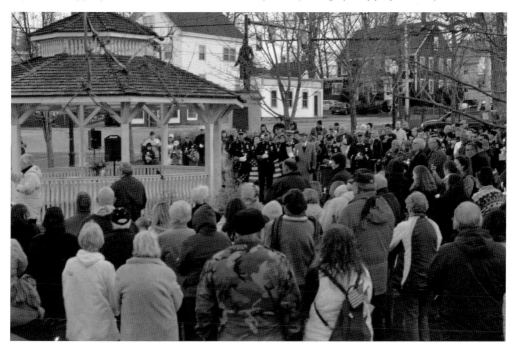

BIBLIOGRAPHY

Graves, Edwin J. comp. *Amesbury's Part in the World War*. Amesbury Publicity Committee, 1919.

Hammer, Kenneth. *Men with Custer, Biographies of the 7th U.S. Cavalry*. Fort Collins: Old Army Press, 1972.

Merrill, Joseph. *History of Amesbury and Merrimac, Massachusetts*. Heritage Books, 1978.

Redford, Sara Locke. History of Amesbury. Whittier Press, 1968.

Rice, Margaret. *Sun on the River: Bailey Family Business 1856–1952*. Rumford Press, 1955.

INDEX

LEGENDARY
LOCALS

AN IMPRINT OF ARCADIA PUBLISHING

Find more books like this at
www.legendarylocals.com

Discover more local and regional history books at
www.arcadiapublishing.com